JOHN HEDGECOE'S
Basic
Photography

COLLINS & BROWN

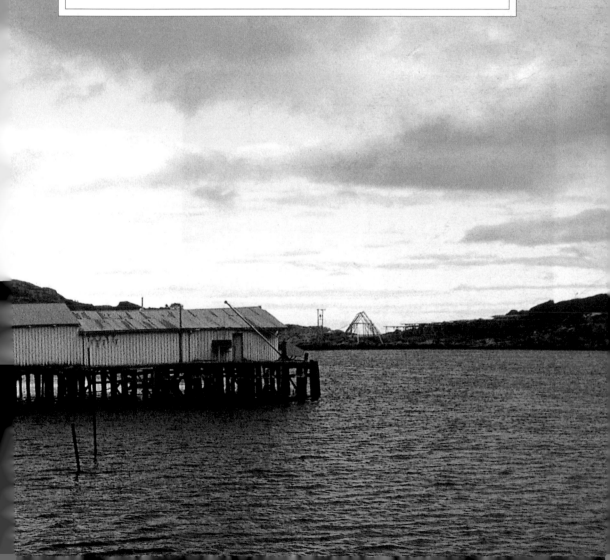

First published in Great Britain in 1993
Revised and updated in 2006
by Collins & Brown
The Chrysalis Building
Bramley Road
London W10 6SP

1 3 5 7 9 8 6 4 2

British Library Cataloguing-in-Publication Data:
A catalogue record for this book
is available from the British Library.

ISBN 1 84340 341 2

Conceived by Collins & Brown
CONTRIBUTING EDITOR: Chris George
DESIGNED BY: Rod Teasdale & Phil Kay

Reproduction by Typongraph, Italy
Printed and bound by Kyodo Printing Co (Pte) Ltd, Singapore

JOHN
HEDGECOE'S
Basic
Photography

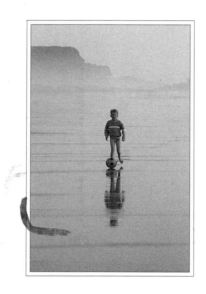

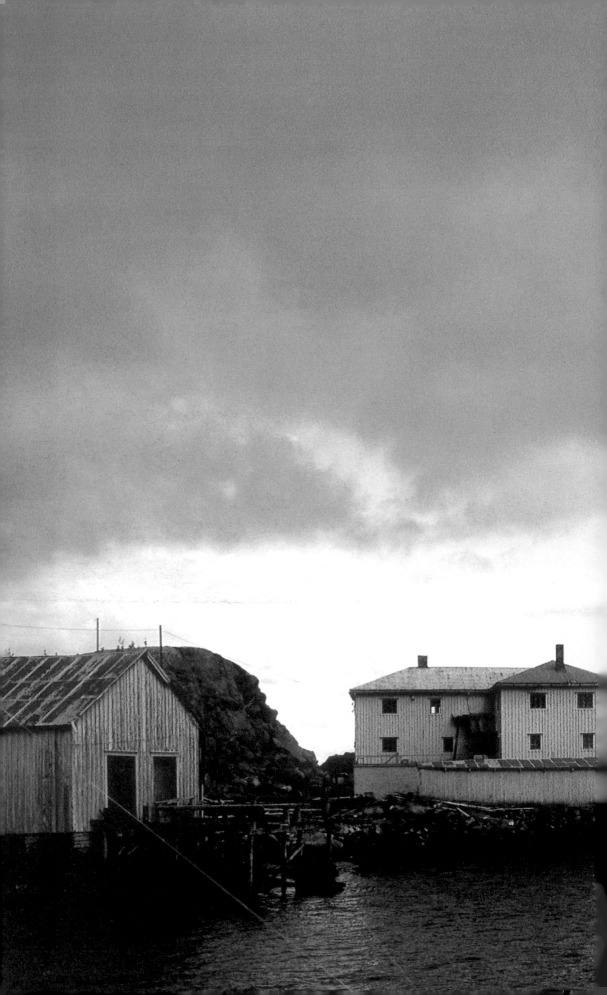

Contents

Introduction

IF THE CLAIMS of the camera makers are to be believed, then every picture taken ought to be a winner. Evermore sophisticated metering and autofocus systems make it seem that all you need to do is press the shutter. Strange, then, that so many people express disappointment when they peer at their results on their digital camera's LCD monitor, or get their prints back.

The reason for this is that good photography has little to do with the type of camera you use. It's just as easy to take a bad picture with an excellent camera as it is to take a good picture with even the most basic piece of equipment. The tendency of many point-and-shoot cameras, digital or otherwise, is to encourage users to confine their photography to the types of situation the automatic settings cope with best. They assume that the subject is the thing nearest to the camera. They try to insist that you use flash after dark – and they perform at their best when the sun is behind you. Many cameras do, of course, offer exposure

overrides, focus locks, and so on, for 'difficult' subjects. As useful as these features are, however, they do all tend to get in the way of the photography.

Taking good photographs means recognizing and then making the most of what your subject has to offer. The first part of this magic formula means really looking at your subject before pressing the shutter. Look out, for example, for features to the side or in the background that would be better included or, just as important, excluded. Check whether your subject is looking directly into the sunlight and is squinting as a result. A slight change of camera position might be all that is needed to improve the composition. At other times turning the subject around or finding some dappled shade might be the answer. Use your eye to explore the possibilities – and then use the technology to make the most of them.

Knowing when to shoot is vital (*below*). A second before and not all the dog would be seen; a few seconds later and the children would be out of shot.

6

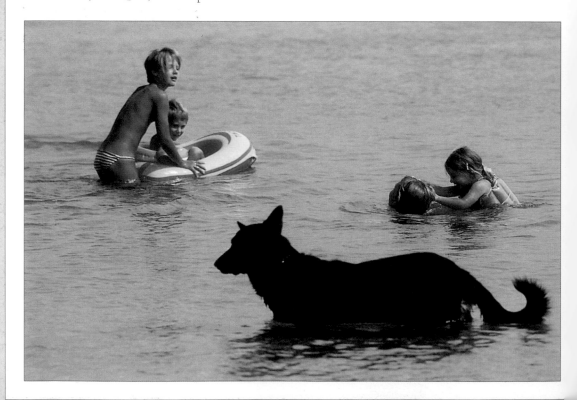

INTRODUCTION

Light does not have to be all-defining to be effective. This simple composition (*right*) gains impact and strength from the limited amount of light entering through a curtained window. The play of light and shade is an important subject element.

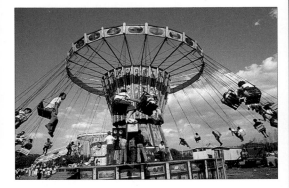

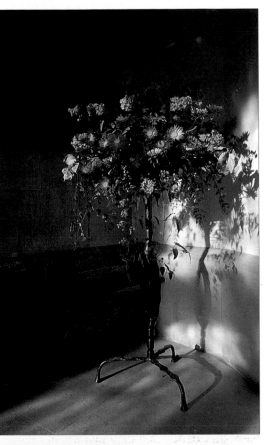

Choosing the best camera position may mean moving around the subject before releasing the shutter. The excitement of the funfair has been heightened here (*above*) by moving in close and shooting with the zoom set to wide-angle looking up at the subjects.

Even a puddle of water after a fall of rain can be effectively exploited (*below*). A reflection can be an important part of the picture, especially if you emphasize it by cropping off part of the subject that is casting the reflection.

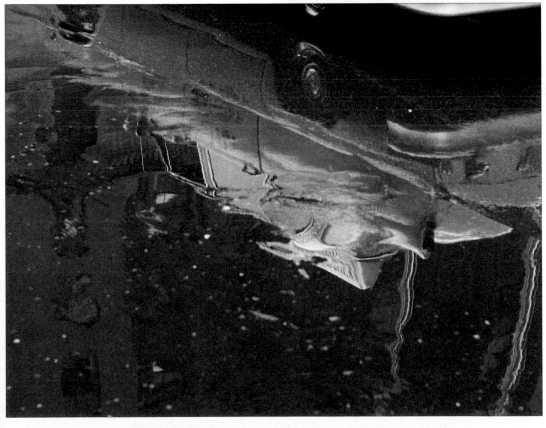

GETTING TO
KNOW YOUR CAMERA

Whether you just want to point and
shoot or really become involved in the
picture-taking process, then the first
thing you must do is become totally
familiar with the way your camera, lens
and accessories work.

How a camera works

Once stripped of all refinements, such as its millions of pixels, its digital circuitry, and motion-tracking autofocus systems and so on, every camera consists basically of a light-tight outer shell with a lens at one end and a light-sensitive strip at the other. Also important is some form of sighting device so that you can aim the camera accurately at the subject. It is the form this sighting device takes, however, that has largely accounted for the two most popular types of camera seen today – the compact and single lens reflex (SLR).

● The compact camera

Although models differ in detail and in the levels of automated and user options available, this is the basic shape of the compact camera (*right*). In order to view the subject, you look through a direct-vision viewfinder positioned at the top of the camera body. The light that actually reaches the CCD chip or film, however, travels a slightly different path, entering the lens directly. The difference in view-point between what you see through the viewfinder and what the lens 'sees' can give rise to a compositional problem known as parallax error (*see box below*). The lens cannot be removed and swapped for another, but many have built-in zooms to help increase the picture-taking options.

● Bladed lens shutter

Since there is only one lens in a compact, unlike an SLR for which you can buy many lenses, the shutter that allows the light to reach the film when you press the release button is located inside the lens. The opaque blades open and then snap closed after a selected period.

Direct-vision viewfinder
Light from the subject enters this window and travels to your eye at the back, giving a direct view of the scene.

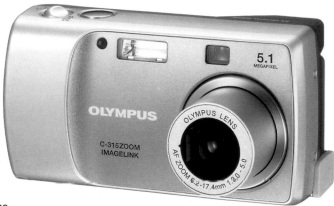

Lens
Light from the subject enters the lens and, when the shutter is open (*below*), travels to the image sensor or film.

Shutter blades partially closed

Shutter blades fully open

Parallax error is the difference between the scene in the view-finder (*right*) and that seen by the lens (*far right*). It is normally a problem only with very close subjects, so always pay careful attention to the parallax correction marks found in the camera's viewfinder.

What you see . . .

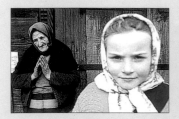

and what the lens sees

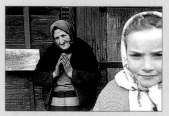

● The SLR camera

The immediately distinguishing feature of an SLR (single lens reflex) camera is the shaped pentaprism on top of the body. Light from the subject passes through the camera lens before striking a 45° angled mirror situated inside the camera body. From here it is reflected upwards, into the pentaprism, the inside surfaces of which are all themselves mirrors. After following a complicated path through the pentaprism, the light exits the camera through the rear viewfinder window. This means that the view you see of the subject is always precisely that encompassed by the lens, no matter what lens is in use, and so parallax error is never a problem as it sometimes is with a compact camera. The price you pay for this precision is not just financial, since SLRs on average are much larger and heavier than compact cameras.

Viewfinder
The same light that enters the lens forms the viewfinder image.

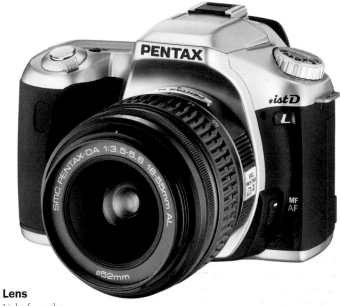

Lens
Light from the subject enters the lens.

11

● How the image is exposed

To allow light through to the back of the camera body, where the film is located, the angled mirror behind the lens swings out of the light path when you press the shutter release. In the diagram here (*right*) you can see that the mirror flips up, and this means that at the moment of exposure the viewfinder blanks out. The shutter of an SLR consists of blinds or blades situated just in front of the image sensor or film, where light is brought into sharp focus (*below*).

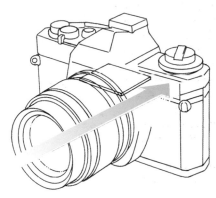

● Focal plane shutter

To avoid the necessity of building a shutter into every SLR lens, the shutter on this type of camera is situated just in front of the 'focal plane', or where the light is brought into sharp focus. The shutter consists of a pair of blinds made of either cloth or metal. The first opens to expose the chip or film to the light, and the second follows to end the exposure. Both are then reset, ready for taking the next picture.

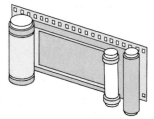

1 Before the shutter release is pressed, the blinds or blades of an SLR's shutter stretch right across the image part of the film.

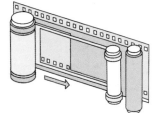

2 To make an exposure, the first blind of the shutter starts to move to the right, allowing light to reach the film.

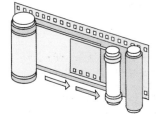

3 The next blind starts to move to close off the light path. The distance between the blinds is determined by the shutter speed.

Choosing a camera

A casual look around a camera store quickly reveals a seemingly bewildering range of different camera types and models. So how do you go about making a proper decision? First, ask yourself if you are likely to want a model with interchangeable lenses and full creative control. If the answer is yes, then you need an SLR; if not, then a compact is your best choice (*see pp. 10-11*). Bear in mind that most compacts now have zoom lenses, which make them far more flexible to use, but no compact comes even close to offering the range of focal lengths available for SLRs. Both SLRs and compacts are available in both digital and film versions – with the former being by far the most popular. Try to resist buying a model that is overly-automated; instead look for cameras that offer you the chance to override exposure and focusing, and that allow you to turn off the built-in flash for low-light shots.

● Medium-range compacts

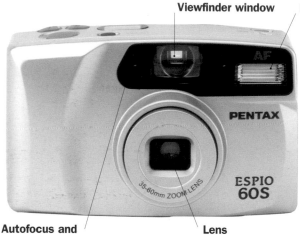

Viewfinder window

Built-in flash

Autofocus and autoexposure windows

Lens

A medium-range compact camera may well have a built-in zoom lens – but the range of focal lengths that it will offer will be limited. Autofocus will be a feature, as will a small built-in flash. Although there may be some special effects, manual overrides will be thin on the ground. If choosing a digital model, ensure that it has both an LCD monitor and a direct-view viewfinder – as an LCD on its own will be difficult to use in bright sun.

● Advanced compacts

These cameras will have all of the features of less sophisticated models, but will almost certainly feature a zoom with a much wider range of angles of view. The lens, too, may have a wider maximum aperture (*see Glossary*), and a greater range of shutter speeds, making it more usable in a wider range of lighting conditions than a lens on a cheaper compact. As well as more sophisticated exposure-measuring systems, advanced compacts may offer a range of manual overrides – but the creative potential is much more restricted than with an SLR.

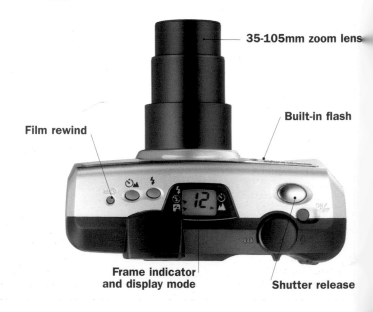

35-105mm zoom lens

Built-in flash

Film rewind

Frame indicator and display mode

Shutter release

12

● Single lens reflex cameras

When considering choosing an SLR, you need to think of it as part of a system. This system consists of the camera body itself, plus the huge number of different focal length lenses and other accessories that are available for it. Lenses range from 8mm fisheyes, which take circular images with a field of view of 180° or more, to massive 1200mm telephotos, which are equivalent to small telescopes. Many SLRs also feature high levels of automation, and five or more different exposure modes with a choice of metering patterns are common. Most offer autofocus, but can be switched to manual focus – with both systems you can see in the viewfinder which part of the scene the lens is focused on. There is usually a small built-in flash, but there will also be a connector for an add-on flashgun as well.

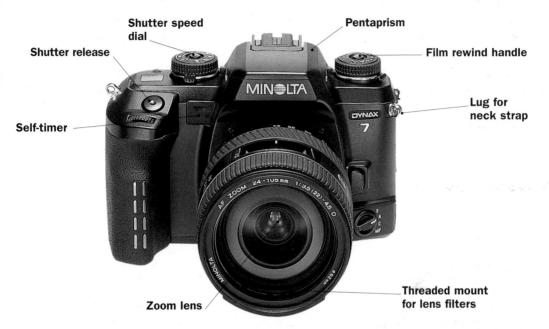

Shutter speed dial

Shutter release

Self-timer

Zoom lens

Pentaprism

Film rewind handle

Lug for neck strap

Threaded mount for lens filters

13

Compacts or SLRs

There is no one best type or model of camera for every picture-taking situation, and your choice of whether to buy a compact or an SLR should depend on the type of photography you are most likely to use the camera for.

For compacts
• Most are light and easy to carry about.
• Point-and-shoot features make them simple to operate even for those with no knowledge of the technical aspects of photography.
• They are excellent for candid photography when pictures need to be taken in a hurry.
• Zoom-lens models allow you a variety of subject framings from the same camera position.

Against compacts
• Many less sophisticated models will take well exposed photographs only in a limited range of lighting conditions.
• On some models the flash fires automatically when light levels are low, making darker-than-normal pictures impossible.
• More sophisticated models demand a reasonable technical knowledge before the options and overrides provided can be used to best advantage.
• Parallax error may occur with close subjects.

For SLRs
• A wide range of different focal length lenses and accessories is readily available, making even the most specialized areas of photography possible.
• Automatic models make point-and-shoot photography as easy as with a compact.
• An extensive range of ISO speeds can be used to aid handheld lowlight photography (see pages 18-19).
• Parallax error is never a problem, since the viewfinder always shows the view seen by the lens.
• Automatic systems can usually be overridden if specific photographic effects are wanted.

Against SLRs
• Most models are larger and much heavier than a compact camera.
• Because of the moving reflex mirror behind the lens, most models are noisier than compacts.
• They tend to cost considerably more to buy.
• During the actual exposure, the reflex mirror blanks out the view seen through the viewfinder – a potential problem with non-static subjects.

Digital cameras

With no film or processing to pay for, digital cameras can prove a wise investment. Instead of using a chemical process, a sensor covered in light sensitive cells (called pixels) turns the image into an electrical signal, which is converted into a digital file and stored on slot-in memory cards. The process is practically instantaneous, and the results can be seen on the built-in screen. You only need to print out or back-up the files for the images that you want to keep (*see pp. 22-23*). Whether buying a digital compact or SLR, one of the key distinctions is the number of pixels that a particular model possesses. Most have several million, but the more pixels available the larger that pictures can be printed out, and the more they can be cropped. The downside, however, is that the higher the resolution the bigger the image files become, using up your available memory faster. To help save space, you can either set a lower resolution, or choose a lower quality setting that squeezes the data into a smaller image file.

● Point-and-shoot cameras

Viewfinder window

5.1 MEGAPIXEL

OLYMPUS

C-315ZOOM
IMAGELINK

OLYMPUS LENS
AF ZOOM 6.2-17.4mm 1:3.0 - 5.0

Built-in flash

Lens

Most digital compact cameras have a built-in zoom – but the range of angles of view offered varies significantly from model to model. Many offer more creative control over the shutter speed and aperture settings than an equivalent film compact. And there are additional controls too. variable ISO sensitivity helps to take handheld pictures in lowlight without the need for flash, whilst white balance controls allow you to tweak the colour balance of pictures for scientific accuracy, or for creative effect.

● Review monitor

The built-in LCD display found on digital cameras not only allows you to review the pictures you have recently taken and share them with others. It also encourages you to. be more ambitious, or even experimental, with your picture taking. By looking at the images you have just shot, you can tweak exposure and other controls with subsequent shots until you get the result that you were hoping for. Unsuccessful images can be immediately deleted, although this should be done cautiously, as there is a risk of deleting the wrong one.

Viewfinder

On/Off switch

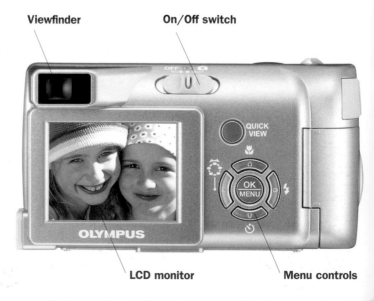

QUICK VIEW

OK MENU

OLYMPUS

LCD monitor

Menu controls

14

● D-SLRs

The advantage of the digital SLR over a digital compact is not just that it provides additional creative controls, and through-the-lens viewing (*see p. 10*). It also works faster. Digital cameras are mini computers, and process millions of bits of data for every picture taken; the processing capability of a D-SLR means there is much less of a delay between pressing the shutter and the image being captured, compared with a typical compact – invaluable for playing children or high-speed sport. The extra brainpower also influences image quality; you would expect images from a D-SLR to have more detail and better colour than a compact, even if the number of pixels were the same.

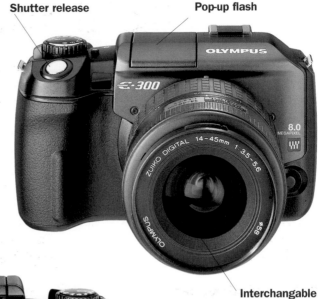

Shutter release

Pop-up flash

Interchangable lens

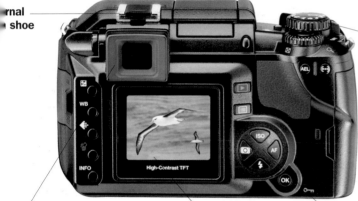

rnal shoe

Exposure mode dial

Eyelevel viewfinder

LCD screen

Menu controls

● System accessories

When you buy a digital SLR, it is possible to just buy the body, allowing you to choose the exact lenses to suit your photographic needs. Although most have built-in flash units, more powerful strobes are available which can be used to light the subject more creatively. Other accessories include grips, which alter the handling characteristics of the camera, or provide a longer-lasting power source.

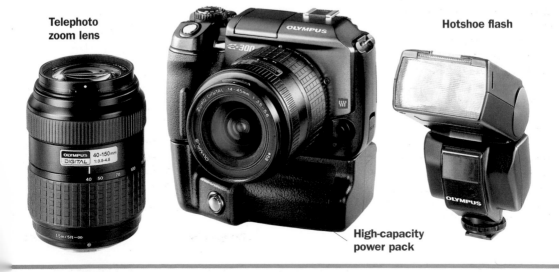

Telephoto zoom lens

Hotshoe flash

High-capacity power pack

15

Film

For those not using digital cameras, there are several different types of film to choose from. The most popular is intended for colour prints; the rest comprises colour slide film, black and white print film, and special-purpose film such as infrared. Colour print film is reasonably inexpensive, there is a wide choice of brands, and film processing and printing costs are very competitive. However, the standard of printing by many processors is poor: if you are consistently unhappy, use another printer.

● The 35mm cassette

All 35mm film comes in either a metal or plastic cassette (*right*). After placing the cassette in your camera (*see opposite*), you pull the shaped film end across the back of the camera until the sprocket holes align with your camera's film-transport system. A light-blocking velvet-covered slot on the cassette ensures that film is not exposed accidentally.

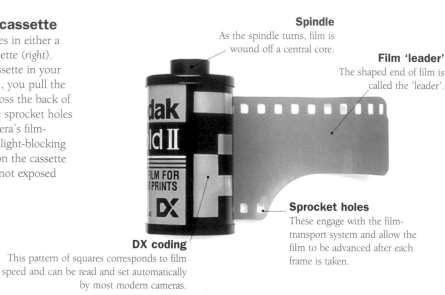

Spindle
As the spindle turns, film is wound off a central core.

Film 'leader'
The shaped end of film is called the 'leader'.

Sprocket holes
These engage with the film-transport system and allow the film to be advanced after each frame is taken.

DX coding
This pattern of squares corresponds to film speed and can be read and set automatically by most modern cameras.

● The APS cassette

The film area used by Advanced Photo System (APS) cameras is smaller than that used by 35mm models – which makes the cameras smaller. The film is not seen by the user – being automatically wound from the cassette to avoid loading errors. Most APS cameras allow the user to change the proportions of the image for each shot – with classic (3:2), HDTV (16:9), and panoramic (3:1) aspect ratios.

Status symbols
Four stage indicator on top of cassette shows whether film is unused, partially exposed, fully exposed but unprocessed, or has been exposed and processed.

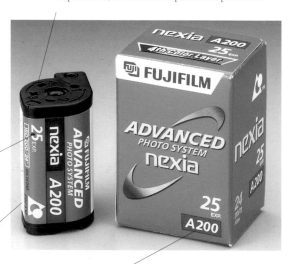

Number of exposures
APS (or IX240) film comes in cassettes with 25 or 40 exposures.

Serial number
A serial number on the cassette is printed on the back of each photo after processing, so that the negatives can be found easily in the future

Film speed
The film speed (*see pp18-19*) is a measure of its sensitivity to light. A low number is useful in bright conditions, with flash, or with a tripod. Higher speeds are better for handheld pictures in duller light.

16

Loading film

Most modern film cameras offer automatic film loading, but some older compacts and SLRs still have to be manually loaded. If a film is not loaded properly it may not wind on after each exposure, or several pictures may be superimposed on a single frame. Alternatively, the film may jam after one or two frames, and the camera will stop working. Automatic cameras usually have some indicator to tell you that all is well and that the film is advancing.

1 Open the camera back and pull up the rewind crank on the left of the camera. Insert the cassette with the film leader at the bottom. Push the rewind crank down again and turn it until it locks firmly with the top of the film cassette.

2 Pull the leader across the back of the camera and insert it into a slot on the film take-up spool (make sure sprocket holes align with the ratcheted wheel). With an auto camera, you usually only have to align the film end with an indicator mark.

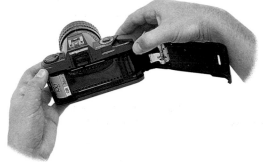

3 With a manual camera, wind the film on until the the film sprockets, top and bottom, have aligned with the ratchets. Make sure the film is winding on securely to the take-up spool – it should be quite tight but not taut.

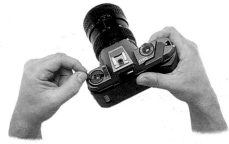

4 Close the camera back. Gently turn the rewind crank in the direction of the arrow until you feel resistance. This will take up any slack film in the cassette so that the film is not bowed and lies flat across the back of the camera.

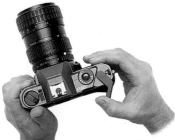

5 With a manual camera, wind the film on until '1' appears in the frame counter window. With an auto camera, simply press the shutter release. If the film is advancing properly, the rewind crank will turn in the opposite direction to the arrow each time.

Remember

• Don't open the camera back unless you are sure the camera is empty or the film has been completely rewound.

• After loading a film, always check that you have set the right ISO number on the camera, unless this is done automatically.

• Load and unload your camera in subdued light whenever possible. If you are outside on a sunny day, turn away from the sun and use your body to shade the camera.

17

ISO speeds

The speed of film is an indication of its sensitivity to light – the more sensitive, or fast, it is, the higher its ISO (International Standards Organization) number. With many digital cameras you can change the ISO sensitivity of the sensor for each shot. Faster speeds require less light in order to give a good exposure than do slower ones, although there is an increase in grain or digital noise.

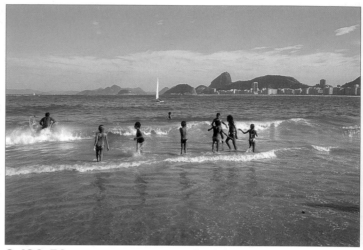

18

● ISO 25

A film of this speed (*above*) is ultra slow and the image should not show any sign of coarseness resulting from the grains of chemicals making up the emulsion.

● ISO 50

A film of this speed (*above*) is twice as fast as one of ISO 25, but it is still a slow film, best suited for use in bright light or with a tripod. The results should be excellent quality.

● ISO 100

This is one of the most common film speed available. ISO 100 is usually the slowest sensitivity selectable on digital cameras, giving the most noise-free results (*below*).

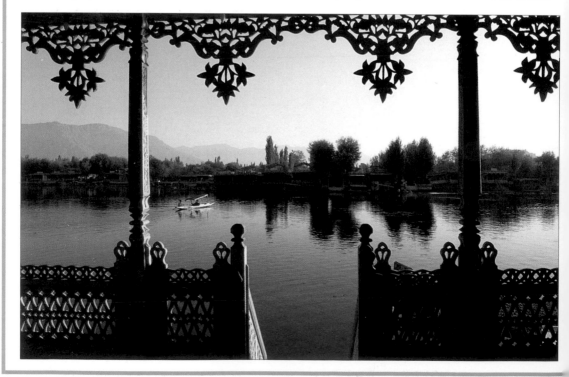

ISO SPEEDS

● ISO 200

This is a medium-speed film or digital setting, ideal for general-purpose photography in a wide range of lighting conditions (*above*). Unless images are very enlarged, you should not see any coarseness.

● Fast film

Fast speeds (*below*) start at ISO 400 and go up to about ISO 3200 for film (and on some digital cameras). A coarse appearance to the image may be a problem, but they are excellent to use with action subjects or in very dim light.

Matching film speed to subject

Whilst digital camera users can change the ISO speed on a shot-by-shot basis, film users need to change film to get the benefit; they must also prepare for all eventualities by carrying a selection of films with different speeds. Bear in mind, however, that fast lenses (those with large maximum apertures) allow more light to reach the film, and so can record a successful exposure on less-sensitive film than can slow lenses.

Slow speeds (ISO 25-100)

Ideal setting or film for any subject where light levels are likely to be high, such as sunny landscapes, brightly illuminated natural history subjects and portraiture. Even when enlarged, prints should be very fine textured and colour reproduction (if carefully printed) should also be excellent. In dim light, a slow shutter speed is likely to result from using this ISO setting (even with the lens at maximum aperture), which may make a camera support essential to avoid camera shake.

Medium-speed film (ISO 200-400)

Popular film speeds which are widely available. Suitable for the types of subject mentioned above under slow speeds, but also for dawn and dusk shots, where light levels are much lower, and for action subjects, such as athletics and indoor photography, where there is sufficient light to make a flash unnecessary. Many digital compact cameras have a maximum ISO setting of around ISO 400.

Fast film (ISO 800-3200)

This speed range should be reserved for low-light photography, where you don't want to use flash or tripod, and for high-speed action shots, where you must use a very brief shutter speed even when the lens is set at maximum aperture. These speed settings is so sensitive that it is possible to take good pictures by, for example, the light of a bonfire at night, or in dimly lit museums.

19

Looking after your camera

Apart from a few obvious and superficial things, modern cameras really do not need a lot of maintenance. As long as you keep its outside and, especially, its inside free of grit and dust and the lens clean you should eliminate the most likely problem areas, both mechanical and pictorial. The lens, however, is delicate and always needs handling with great care. Old batteries are more prone to leaking than new, so never leave spent batteries inside the camera.

● Cleaning kit

The most important item for regular camera care is a blower brush. This rubber bulb of air has a brush attachment that is ideal for dislodging dust from corners and crevices. A fairly stiff paintbrush is fine for cleaning the broader flat camera surfaces and non-glass parts of the lens. If you always keep your fingers off the lens, then all you should have to cope with is dust, which can be removed using special lens tissues or a lens cloth. For greasy marks, however, you will have to use a lens-cleaning fluid – but regard this as emergency treatment only.

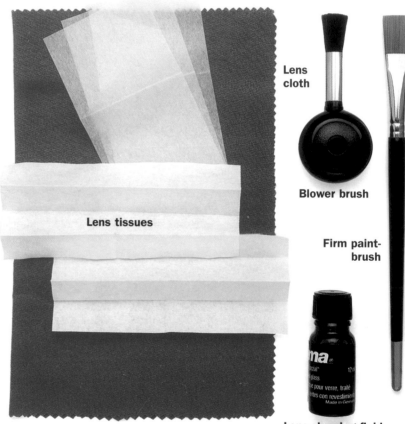

Lens cloth

Blower brush

Lens tissues

Firm paint-brush

Lens-cleaning fluid

Preventative care

• Whenever possible, each time you download images from a memory card or change films, carry out a basic cleaning routine.

• LCD screens on digital cameras are prone to fingermarks and scratches. Use a protective cover, if available, and keep in a case when not in use.

• Never leave batteries inside the camera for extended periods, and remove spent batteries promptly. Old batteries may leak a corrosive fluid that can seriously damage the camera.

• An ultraviolet filter left permanently over the lens of cameras that take filters will not affect pictures but it will protect the lens from dirt or grease. The filter can be taken off and cleaned, and if it does become scratched it can be cheaply replaced.

• Always keep your camera dry. Protect it if it starts to rain, and especially keep it away from salt sea spray, which is corrosive.

• Keep memory cards in protective cases when not in use, to avoid damage to the metal contacts.

LOOKING AFTER YOUR CAMERA

● Cleaning a compact camera

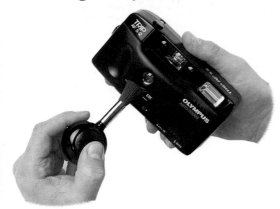

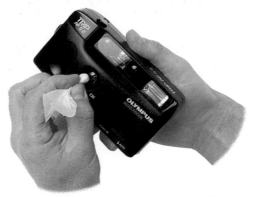

1 Using a blower brush, brush any dust off the front of the lens (or filter, if used). The lens is delicate and easily scratched, so avoid touching it. Hold the camera so dust falls down, out of the way.

2 If the dust is stubborn, use a small piece of lens tissue to clean the lens. Make sure the tissue is clean, and wipe gently using a circular motion. A special lens cloth may also be used.

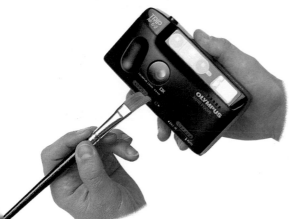

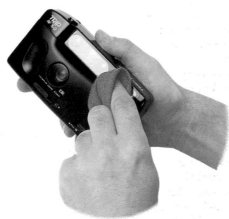

3 Using an ordinary, firm-to-stiff paintbrush, clean all the flat surfaces of the camera. Make sure the bristles of the brush do not accidentally scratch the lens, however.

4 The front viewfinder, autofocus and autoexposure windows need to be kept perfectly clean to ensure problem-free photography. Use a clean, soft, lint-free cloth for this.

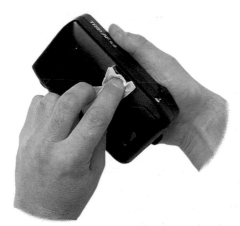

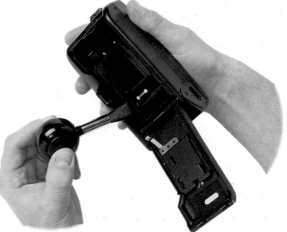

5 Turn the camera around so that you can now clean the back. (Make sure your hand does not touch the front glass element of the lens.) Use a lens tissue or cloth to clean viewfinder eyepiece and LCD screens.

6 With the back open (film cameras only), use a blower brush to remove any dust. Check that the plate on the camera door is grit-free. Finally, check that no hairs from the brush have fallen off inside.

Digital image storage

In theory, digital cameras cost little to run. Images do not need processing, the memory is reusable and even the batteries are often rechargeable. However, although digital images do not have a physical form, the amount of storage space available on the camera is not limitless. There comes a time, when the image files that you want to keep need to be copied to and archived onto some other form of digital storage device – and possibly even turned into hardcopy prints. As digital images can take up more memory than most computer files, and because it is all too easy to delete them accidentally, it pays to be careful about how you archive your ever-growing library of shots.

● Flash memory cards

Although some digital cameras have a built-in memory, most models store images on slot-in flash memory cards. There are many different types, and only one or two will work with your camera. The capacity of the card is all-important. Measured in megabytes (MB) or gigabytes (GB, equal to 1024MB), its capacity will dictate how many images that you can store. By altering the resolution and quality settings (*see p. 14*) you can squeeze on more images – but this sacrifices quality. It is better to use a high quality setting, maximising an image's future usability, and buying a more capacious memory card. You need a card (or cards) that will allow you to keep shooting until you next have a chance to back-up the images.

One gigabyte memory card

● Computer connections

Digital cameras can be thought of as another computer peripheral – like a scanner. It provides a way of inputting data into the PC's digital domain. For most photographers, the computer is also the most obvious place to download successful images to. Digital cameras can be connected direct to a computer with supplied cables, and handle much like an external drive. Alternatively, use a low-cost card reader. With the aid of image editing software (*see pp. 148-153*) your images can be manipulated and improved in a myriad of ways. If the space on the hard drive starts to run out, images can be archived onto recordable CDs and DVDs, or onto an external hard drive. Keep additional backups of valued images as a precaution to guard against accidental deletion, fire, theft or hardware failure.

Apple Mac computer

22

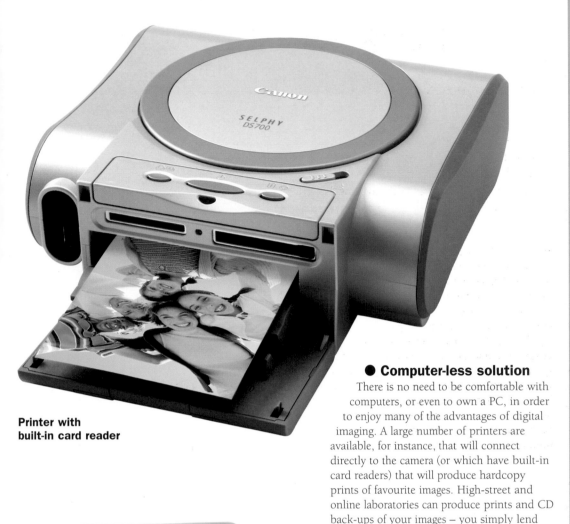

**Printer with
built-in card reader**

● Computer-less solution

There is no need to be comfortable with computers, or even to own a PC, in order to enjoy many of the advantages of digital imaging. A large number of printers are available, for instance, that will connect directly to the camera (or which have built-in card readers) that will produce hardcopy prints of favourite images. High-street and online laboratories can produce prints and CD back-ups of your images – you simply lend them your memory card, or upload the image file using email or the internet.

Portable hard drive

● Portable memory

Camera memory cards are relatively expensive – otherwise you would be tempted simply to buy a new one every time you needed more capacity. You rely, therefore, on having just enough portable storage available until you can get back to base, where pictures can be downloaded and memory freed up for another day's shoot. However, what do you do if you are going to be away for longer than usual? A number of different solutions are available aimed at the travelling photographer. Portable hard drives that run on batteries are available which connect direct to the camera; these often have a built-in LCD screen for viewing the images stored and typically have a capacity of around 40GB. An alternative is a portable battery-driven CD or DVD burner. A laptop may also be used for image archiving and on-location editing.

TWENTY WAYS TO
IMPROVE YOUR PHOTOS

We all want our pictures to have an eye-catching quality, something that makes them enjoyable to look at. This chapter offers a variety of easy techniques you can use to do just that – ones that, once learned, soon become simple reflex.

1 · Look for the light

The basis of all photography is light. The word 'photography' means 'drawing with light', so it is surprising that many camera users don't recognize that daylight has many varied moods (*see pp. 100-3*), and can paint a variety of different pictures depending on the time of day, the season, weather conditions, as well as local factors such as the proximity of tree cover or large buildings. The trick is to really look – and see – just how the light is affecting your subject.

● Direct sunlight

A high, strong sun washes this brightly clad child with light (*below*), drawing out from the picture a warmth that has as much to do with the gaiety of her costume as the intensity of the sunshine illuminating her.

● Blue sky

A different picture here (*right*) compared with the one below. The same costume is being worn, but now the light is coming from a blue sky with no direct sunlight at all to add warmth and brightness to the image.

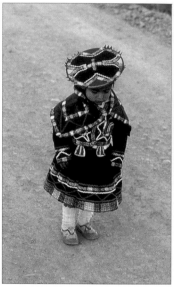

26

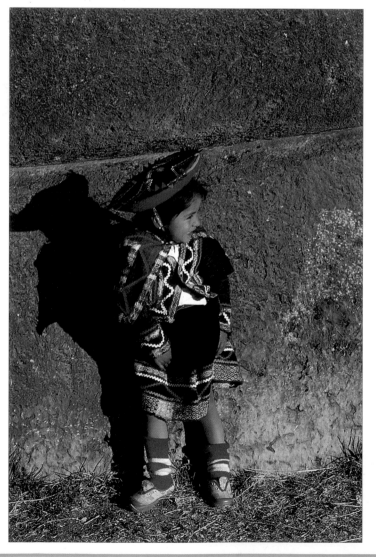

Try for yourself

• Don't feel constrained to accept the lighting conditions as you initially find them. If your subject is mobile, then try shooting in both direct sunlight and then move into full or dappled shade to create a different mood or atmosphere.

• If your subject is fixed and immobile, or perhaps it is a broad landscape scene, then you still have the option of finding a camera position where the light is more favourable or it accentuates some prominent feature.

• Filters are available (*see pp. 142-3*) that fit over the lens of suitable cameras and subtly change subject colours.

● Lighting quality

If you take the time to look you will find a wealth of different lighting moods and atmospheres simply as a result of shooting at different times of the day.

Morning

Pictures taken early in the morning (*right*) often contain soft, gentle shadows where the sun has not yet penetrated, coupled with delicately warm highlights wherever prominent features can be seen.

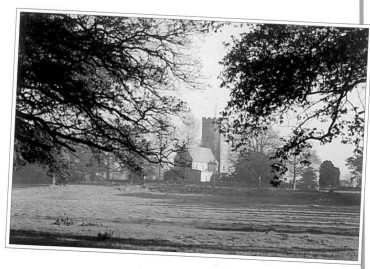

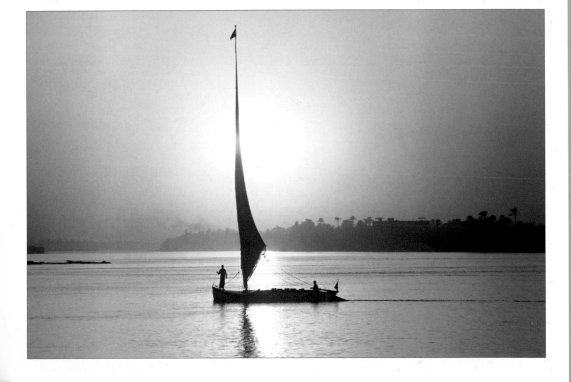

Afternoon

In late afternoon, the sun is sinking lower in the sky and subject shadows start to lengthen and deepen (*left*). Where the light does strike, however, you tend to see a rosy warmth unlike other times of day.

Sunset

At sunset (*below*) the light from the sun travels through a great volume of atmosphere, where only the fantastic orange and red wavelengths can penetrate.

27

2 · Use colour for best effect

Colour affects the mood of photographs. A splash of bright colour in dim or gloomy surroundings can enliven results and focus attention on a special part of your picture. Large areas of strongly contrasting colour in the same shot, however, can be distracting and may compete with the subject for attention.

● Dominant colour

Here (*right*) two colours compete for attention. Although the area of blue wall is far larger than the yellow of the woodwork, the colder blue colour seems to recede into the background as the warmer yellow moves forward in the frame. The yellow thus dominates, and the overall effect is strongly three-dimensional.

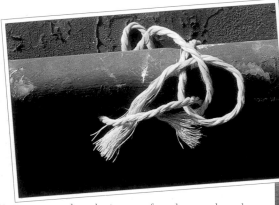

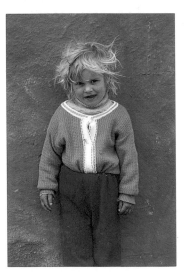

You can strengthen the impact of a colour, such as the yellow of this rope (*above*), by shooting it against a plain, dark background. Although the light striking the rope and the top of the supporting pipe and wall is about equal in strength, the yellow glows out of the frame, dominating its surroundings.

● Colour contrast

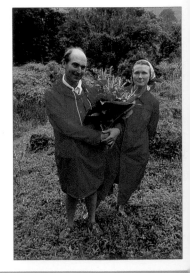

A strongly contrasting background (*left*) can become the focus of attention in a photograph at the expense of the main subject. When your subject is wearing brightly coloured clothes, as here, try to find a more neutral colour to act as the backdrop.

You can make colour contrast work in your favour by restricting the number of hues. Here (*right*) the camera position has isolated the two figures in red against a solid background of green, a colour contrast that is repeated in the flowers being cradled by the male figure.

28

● A touch of colour

In this setting (*right*), the overall coloration of pale cream merges with the yellows on the base of the urn and the muted terracotta in the paved terrace. The only relief comes from the warmer pinks of the begonia flowers, which, although small in the frame, inevitably attract the eye and become a focal point.

When the range of colours is limited, those that you do include in the shot become far more important. The touches of colour represented by the yellow bedposts (*above*), immediately attract the eye in an otherwise colour-free frame.

29

● Colour harmony

Festive red of the baby's jumpsuit (*above*), repeated in the gift wrappings, establishes a colour harmony that leaves nothing discordant to distract the eye.

The purple of the foreground display of geraniums (*above*) creates a link with the woman's purple shirt, an harmonious arrangement repeated throughout the frame.

Try for yourself

• The apparent strength of a colour often depends on its surroundings. Place a coloured object against a light background and then the same object against a dark one. Colour looks stronger when viewed against the light surroundings.

• The stronger the light illuminating your subject, the brighter the colour looks. Try photographing the same coloured object lit by the weak rays of early morning sun and then by strong sunshine around mid-day.

• If available on your camera model, set the exposure override control to $-\frac{1}{2}$ or -1 to make colours look deeper and richer in the final print.

3·Make shape the subject

Sometimes, the impact of the main subjects or features of a photograph can be significantly enhanced by simplifying them largely to shape. Shape is one of the key factors in our recognition of people and objects, and their shape becomes more apparent when surface details are removed, or at least suppressed. Look for uncluttered, bold subjects, perhaps seen against a plain backdrop such as the sky. Moving in close may be one way of simplifying a complex shape.

● Near and far shapes
By moving close to the boatman for this shot (*right*), all extraneous clutter has been removed. Note that the shape of his body and diagonally held pole make a powerful subject, especially when seen against the distant, simplified shape of the Taj Mahal.

● Silhouetted shapes
By exposing for the sky, which is the brightest part of this image (*below*), the storks, nestlings, nest and pole have all been reduced to graphically simple silhouettes. This does not interfere with recognition, however.

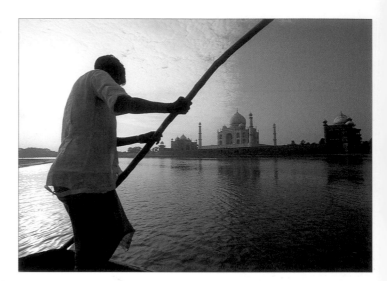

30

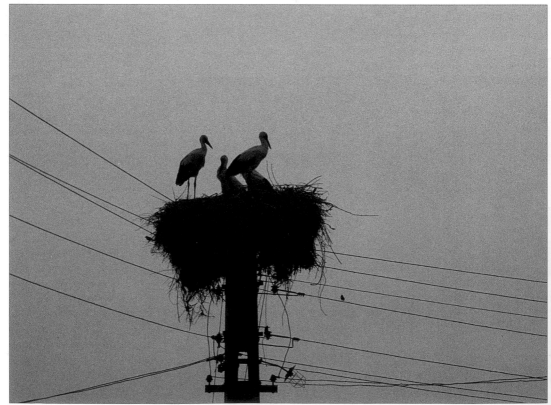

● Use the weather

Mist, heavily diffused daylight, the gloom before a storm, and dusk light can all be viewed as welcome opportunities for you to emphasize subject shape.

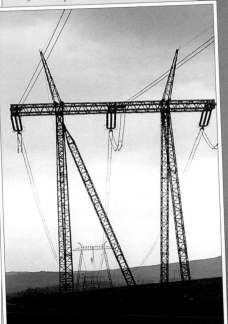

Overcast light

Although perhaps not an obvious choice of subject (*above*), backlighting evocatively emphasizes the dramatic shapes of the pylons.

Sunset silhouette

Sunsets are photogenic subjects (*right*), but they need something else in the frame to provide a focus of attention. Here the silhouette of the church dome does the job.

Try for yourself

• To see how you can emphasize subject shape over and above its other attributes, initially photograph it against a richly detailed backdrop of, say, trees.

• Next, come in closer to the subject, so that you are almost at its base, or feet if using a person. Now, shoot steeply upwards so that the subject is seen against a plain sky.

• Shooting into the light leads to loss of subject colour and detail; shooting with the light gives the opposite effect. Take one picture with the sun positioned directly behind the camera so that it is fully illuminating the side being shot.

• Next, move right around to the other side of your subject so that the light source is now shining into the camera lens and the side of the subject being shot is in deep shadow.

• To visualize how a subject will look with detail and colour suppressed, take your eyes slightly out of focus as you look at it.

4 · Bring out subject form

Have you ever noticed that when looking at some photographs you get the feeling that you could reach out and actually touch the person or object depicted? Often this is because the lighting – usually oblique – has emphasized the three-dimensional aspect of the subject's form and made the image appear rounded rather than flat. Although this may sound technical, it's all really just a trick of the light.

● Form-flattening light

This photograph (*right*), with soft light flooding the figure from the front, tends to flatten any form-creating shadows. In addition, the model's face and hair, as well as the background, are all approximately the same tone, and the overall impression is of a soft, high-key beauty photograph.

32

● Form-enhancing light

Here (*left*), using the same model as above, you can see what a difference a change in lighting direction can make to your subject's appearance. Lighting from below has rounded out her chin, made her lips fuller, and helped to define her cheeks, eyes and hair.

Try for yourself

• Find a fixed subject – say, a statue in an open space such as a park. Take one picture with the sun behind you so that the subject is frontally lit. Next, move around so that the subject is lit from the side, and take another. The second picture should show more subject form.

• Alternatively, keep the same camera position for both pictures and wait for the sun to move in the sky between shots.

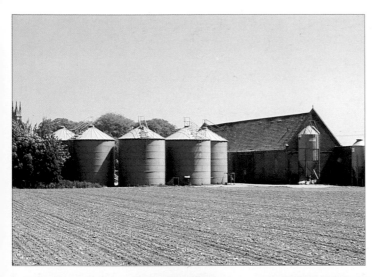

● Full sunlight

In this photograph (*left*) it's possible to see how the same light source can both accentuate and suppress the form of objects in the same picture. The sun is strong and quite high in the sky, too high to throw shadows into the hollows of the lightly ploughed foreground field. The cylindrical storage silos and barn in the background, however, catch the sunlight at an angle, so that some surfaces are lit while others remain in shadow. As a result, the modelling tones – from light to dark – show the forms of the silos very clearly.

● Low sun

Although bright, the sun is now low and just gently warm (*above*). In stronger light, the white woodwork and rippling water would have glared back at the lens. But now, subtle gradations of colour and tone, light and shade, define every surface feature.

● Toplighting

Lighting from above and behind the subject is usually not very satisfactory. In this picture, however (*left*), it has produced a real sense of roundness and solidity by creating a tonal range that emphasizes the form.

5·Emphasize subject texture

Capturing the surface texture of an object in a picture is the best way to
communicate how it would feel if you could reach out and touch it. By moving
in close, and perhaps using the macro setting found on many modern zoom
lenses, you can isolate just a part of the object and make texture the main
subject of the shot. More often, however, texture is simply one of the elements
in a picture, one that adds extra interest and information about the subject itself.

● Material

If you look closely at these shorts
(*right*), you will see that the light is
casting shadows downwards,
emphasizing the folds of material
and indicating that the sun is high
in the sky. This lighting also suits
the finer texture of the well-worn
belt and the silkiness of the girl's
skin just visible above.

● Skin

The heavily creased texture of this
woman's face (*below*) makes a
powerful image, an effect that is
strengthened by the contrasting
smoothness of the headscarf
framing her face.

34

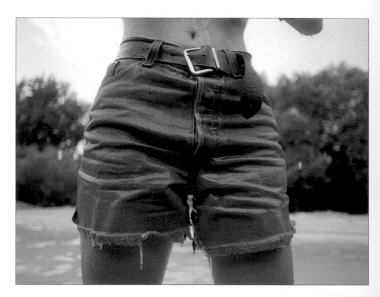

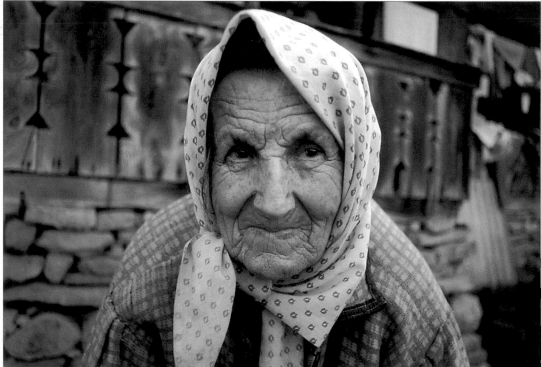

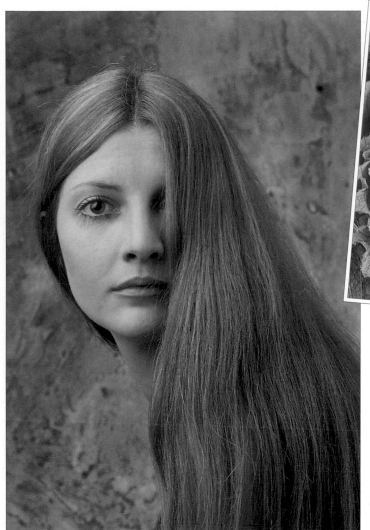

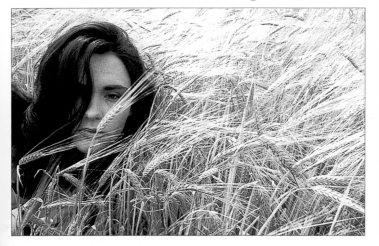

● Leaves

A delicate subject often requires a delicate light to bring out important surface details (*above*). Here, soft lighting from the side of the cabbage grazes the tips of the leaves, leaving the heart of the plant in slight shadow.

● Perfect skin

Texture is all-important in portraits. Often we want to emphasize the smooth skin of a model (*above*) – at other times we need to hide those frown lines and wrinkles.

● Wheatfield

An overcast light (*below*), with the sun partially obscured by clouds, has transformed a field of wheat into a carpet of spun gold flowing around the girl's dark hair.

Try for yourself

• Texture is more pronounced if the light strikes the surface of the subject from the side or top, rather than from the front or rear. Place a ball of wool or string on a table and move an ordinary lamp in an arc from one side to the other, while you carefully watch the effects of the light on the ball's surface appearance. When the light is almost parallel to the surface, the texture will be most prominent.

• Light from the side or top can cast very deep shadows, which may be unattractive. If so, try placing a piece of white cardboard on the subject's shadow side, out of range of the lens, to reflect back some light and so lift the shadows a little.

6 · Find and use subject pattern

The presence of pattern can add extra strength and a sense of purpose to your photographs, and, once you start to look, you will find patterns of one type of another in many scenes. Pattern may simply be a repetition of shapes or colours, or it may be the play of light and shade as sunlight filters around an obstruction. Sometimes, however, you will have to isolate part of a general scene in order to concentrate attention on a particular area contained within it.

● Repeated shapes

The pattern in this shot (*right*) comprises the repeated shapes of the hubs, rims and spokes of the wagon wheels. Although a sunny day, the wheels are all in the shade, which brings out another pattern – the consistent colour of the weathered wood.

● Pattern within pattern

The obvious pattern here (*below*) is the shapes of the shoes, but if you look closer, the decoration on the shoes, even the way they are constructed, all combine to make patterns within patterns.

36

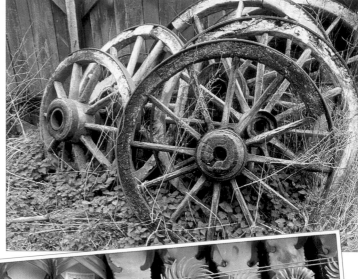

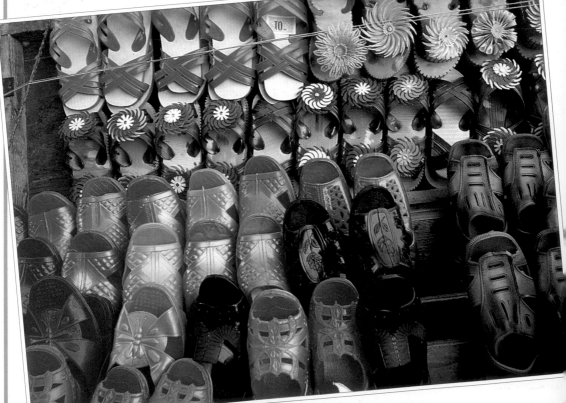

6·FIND AND USE SUBJECT PATTERN

Try for yourself

• Seeing pattern in scenes often has a lot to do with the camera position.

• Find a subject, such as a row of houses, a ploughed field, a line of parked cars, containing repeating shapes, angles or colours.

• Looking through your camera viewfinder, move around the subject, trying low and high angles, too, until you see pattern most strongly represented.

● Pattern as subject

Light filtering through trellis panels set in the roof (*right*) casts patterns of squares on the figures and room beneath. Now pattern itself has become the main subject of the photograph, and the figures and setting are secondary in importance.

● Angular pattern

Seeing pattern in ordinary scenes, such as in this collection of whitewashed buildings (*below*), is a matter of practice. Note that virtually every line in the shot is either straight or angular, which creates a strong, unifying effect.

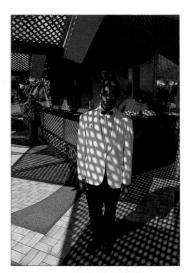

● Isolated detail

To concentrate on pattern like this (*right*), view the scene via the camera so that it is confined by the edges of the focusing screen. With a zoom, move the lens in and out to simplify the elements to the bare essentials. Moving nearer and farther with a fixed lens may have the same effect.

7 · Give your pictures depth

Giving the image on a flat, two-dimensional photograph the perspective of depth can be achieved using certain visual tricks. One of these is linear perspective and involves us recognizing that as parallel lines extend into the distance they appear to converge. Another is diminishing scale – as things get farther away, they appear smaller. And another common one is aerial perspective, or the tendency of colours to appear more blue the more distant they are.

● Diminishing scale

As the Buddhas are the same size, we know the 'smaller' ones are farther away (*below*). A wide-angle lens exaggerates this effect of perspective.

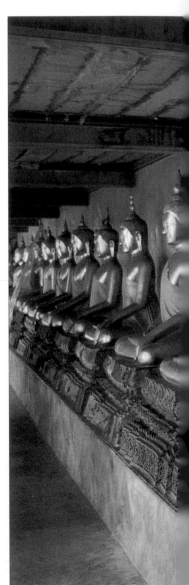

● Aerial perspective

In this example (*above*) you can see clearly the effect known as aerial perspective. The lightening in tone and strong blue of the mountains automatically imply great depth.

● Linear perspective

We know that the edges of the path in this picture (*right*) are parallel, so their apparent convergence implies depth. You can strengthen this effect, as here, by using a wide-angle lens to make the near path edges seem wider, hence steepening perspective.

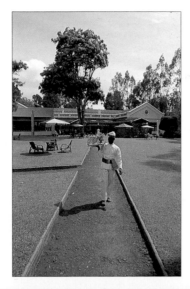

Try for yourself

• Take one photograph with the camera looking down, say, a straight path or road at a subject a fixed distance away. Next, move your camera position 90° so that the subject is the same distance, but now you are looking across the path or road. Compare the differences.
• Find a line of trees all the same size. Take one picture with the nearest tree small in the frame, and another with it large in the frame. Again, compare the differences.

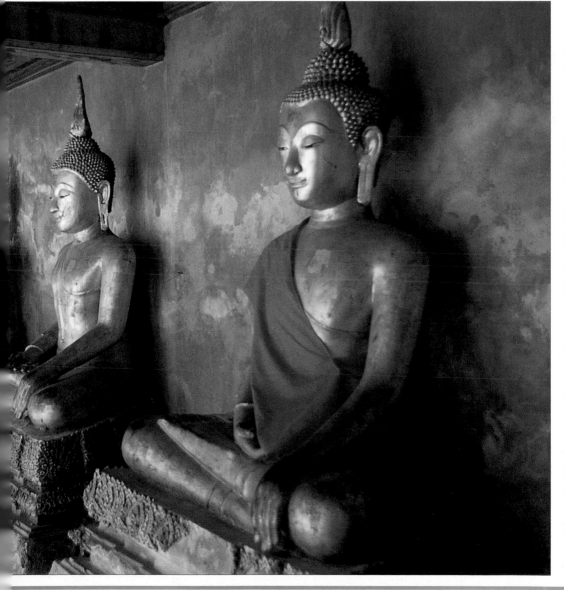

8 · Turn the camera around

All digital cameras, and most film cameras, give you the chance to frame your subject horizontally (often called a landscape view) or vertically (a portrait view). Which you choose depends entirely on the needs of the subject. A cityscape featuring tall buildings, for example, may benefit from vertical framing to emphasize the height of the structures, while a broad landscape scene may demand horizontal framing. If in doubt, look through the viewfinder and turn the camera around before shooting.

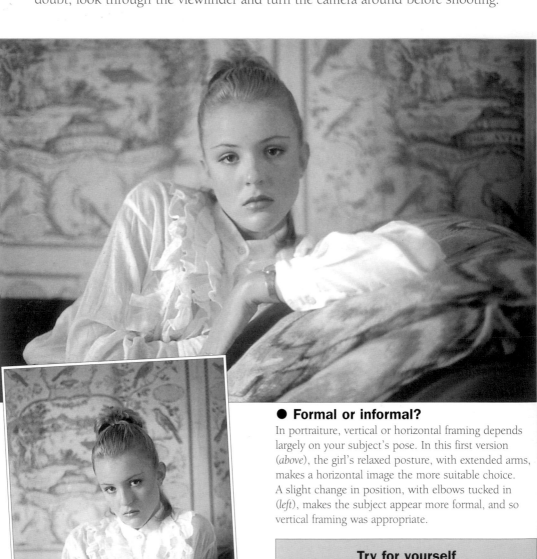

● Formal or informal?

In portraiture, vertical or horizontal framing depends largely on your subject's pose. In this first version (*above*), the girl's relaxed posture, with extended arms, makes a horizontal image the more suitable choice. A slight change in position, with elbows tucked in (*left*), makes the subject appear more formal, and so vertical framing was appropriate.

Try for yourself

• Find a range of subjects, such as a landscape, cityscape and portrait figure.

• Take two pictures of each, one with the camera held vertically and the other with it held horizontally, and compare the results.

• Turning the camera around may enable you to crop off unwanted subject detail.

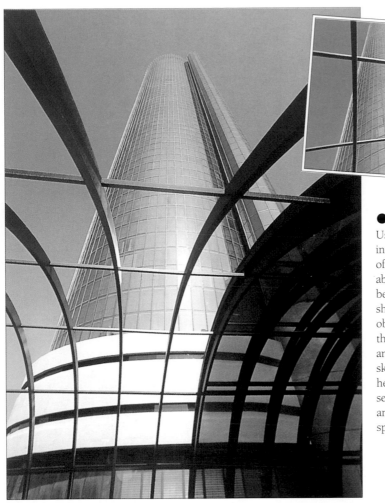

● Tall buildings

Using reflections in order to include more of the surroundings of a subject or to create a semi-abstract image (*see pp. 126-7*) may be a very useful device. As a first shot, vertical framing was the obvious choice here (*left*), since this emphasizes the upward thrust and towering height of the skyscrapers. But with the camera held horizontally (*above*), you can see more of the surrounding scene and the image seems to have more space and air.

41

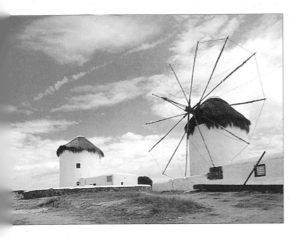

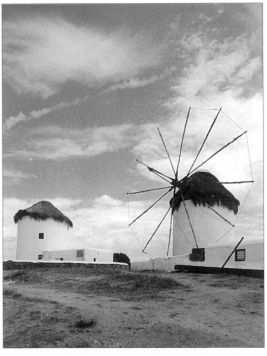

● Landscape scenes

Framing can alter the emphasis of a picture. With the camera held vertically (*right*), there is a strong relationship apparent between the foreground and background elements of the picture. However, a horizontal view (*above*) includes a greater sweep of scenery and also imparts more of a sense of flow across the frame.

9 · Change the viewpoint and angle

Your choice of viewpoint and camera angle can both have a dramatic impact on even a simple photograph. Before you press the shutter, experiment by moving around your subject, looking through the viewfinder all the time, to see exactly what else will be included in the picture as you move to the left or to the right, say, or more to the front or to the rear. Tilting the camera up or down may also give a more interesting or unusual slant to an everyday type of subject.

● Bad camera angle

In this image (*left*) the intention was to show the statue and the building behind as both being important elements of the shot. A head-on camera angle, as you can see, has caused utter confusion. The statue's head coincides with the tower of the building, and a large percentage of the building is obscured anyway by the statue's plinth.

● Better camera angle

By moving slightly farther away from the statue, and also moving in an arc to the right in order to get closer to the building, the appearance of the subject elements in this next shot has changed quite a bit (*right*). Statue and building are now sufficiently well separated not to cause confusion or conflict and one of the building's better features, the area surrounding the main door, is now plainly visible.

● Look down

This bizarre image of brightly coloured boats and canoes on the emerald waters of a river cut deep into a barren, rocky landscape (*left*), has been given real impact by a high camera position. This effect has been strengthened and reinforced by the type of viewpoint you get with a wide-angle lens setting. The same combination of camera angle and focal length (*right*) has turned an unlikely subject for a photograph into a real winner. Both images also show another characteristic of wide-angle lenses or lens settings – aerial perspective (see p. 38).

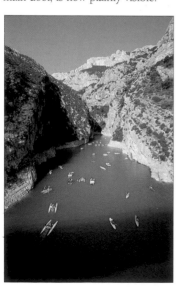

9•CHANGE THE VIEWPOINT AND ANGLE

● Lens and positioning

Sometimes you will need to change lens focal length and camera angle to achieve the best result. The first shot (*right*) reveals a conflict between the tower and steeple. By moving closer to the castle wall and zooming in slightly to bring the tower up in size (*below*), the main subject (the tower) is now more obvious, although the detail of the spire can still be seen.

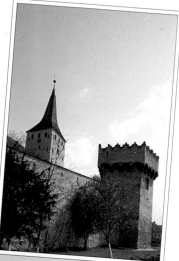

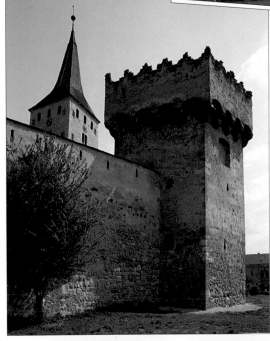

Try for yourself

• If you have an SLR with different lenses or a zoom compact, take a wide-angle picture with a near subject and a detailed background.

• Change to a telephoto lens or setting, move back so that the subject is the same size in the viewfinder, and take another picture. When comparing results, look in particular at how changing focal length affects the relationship between fore- and background elements.

● Look up

It is easy to fall into the habit of looking straight ahead, with the camera held to your eye at your normal standing height, looking neither down (*see opposite*) nor up. And many a good picture is missed as a result. In the photograph of a classically inspired fountain and monument (*below left*), the lens was set to wide-angle and a shot taken close up to the base of the fountain with the camera tilted back. The effect known as converging vertical lines is very evident as a consequence. This is seen even more dramatically in the next image (*below centre*). This was taken with the photographer lying flat on his back with the camera and lens, set to wide-angle, looking directly up at the surrounding trees. Many interesting architectural details and embellishments on buildings are positioned far above head height, and can be seen in detail only by looking up using a zoom lens set to a long telephoto setting (*below right*).

43

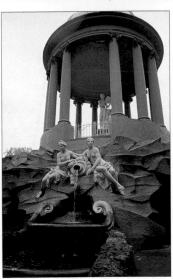

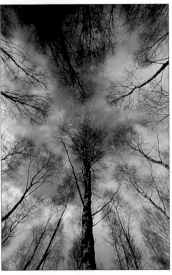

10 · Shoot around the subject

When coming across a view you have never seen before, don't just photograph it from the first convenient position – take the time to walk around to see if you can make your shots more exciting or dramatic. Sometimes, moving just a little to the left or right may bring a new feature into the frame, or help clear an obstructing foreground element. Always use the camera's viewfinder to check composition from every angle.

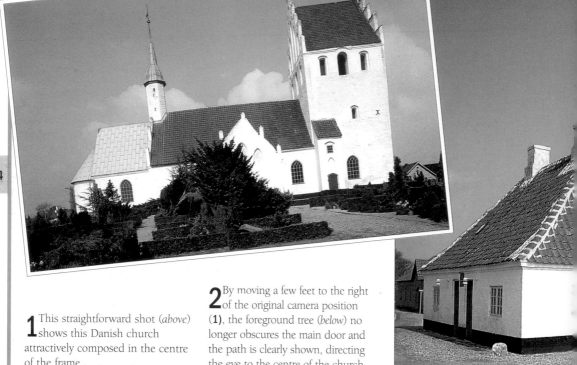

1 This straightforward shot (*above*) shows this Danish church attractively composed in the centre of the frame.

2 By moving a few feet to the right of the original camera position (**1**), the foreground tree (*below*) no longer obscures the main door and the path is clearly shown, directing the eye to the centre of the church.

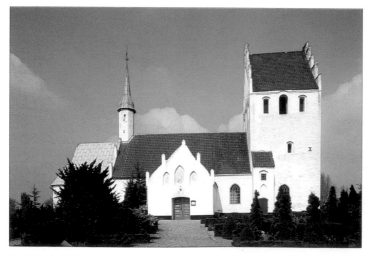

Try for yourself
• Pick any reasonably open location, such as your back garden or a small park, with a centrally placed subject – a person, object or structure.

• Take a set of pictures moving around the subject to see the effects the changing background and foreground have on it. Try to vary the height of the camera, too, so that some shots show the subject framed against the ground, some the sky.

44

3 This view of the church (*right*), although not filling the picture area particularly well, is important since it tells us the date of construction.

4 You can see that by changing camera position (*below*) the date is still visible on the tower, but an outbuilding now occupies the previously empty foreground for a more pleasing effect.

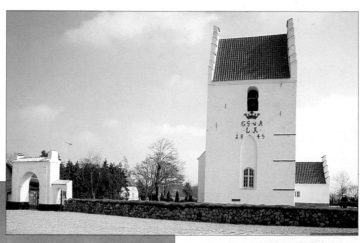

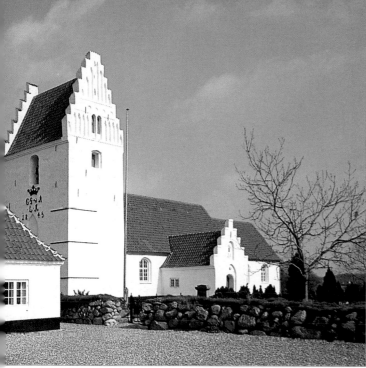

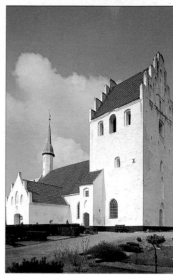

45

5 To emphasize the height of a building, turn the camera on its side to give a vertical image (*above*). A low camera angle has increased the upward thrust of the tower.

6 When looking for new shooting angles, keep an eye out for features such as the paths in this view (*right*). These act as 'lead-in' lines, which take the viewer's eye directly to the main subject and help to strengthen the shot's impact. This camera angle was chosen so that the main door was still just visible.

11·Keep it simple

On many occasions, what you choose to leave out of a photograph is as telling as what you decide to include. Although there are no golden rules when it comes to photography, pictures are often stronger if they do not contain too many competing elements. Before taking every shot, look carefully through the viewfinder to see if everything there is working in favour of the composition. If not, reframe the image to simplify the subject matter.

● Confused subject

There is so much going on in this photograph (*right*) that it is difficult to see exactly what the subject of the shot was intended to be. Is it the food display in front, the staff behind or the over-powering wall decoration at the rear? The overall result here is highly patterned and very confusing.

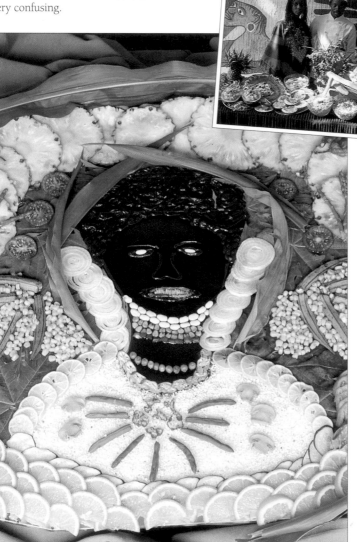

● Telling detail

By shunning the temptation to capture the whole scene, as in the view above, this simplified shot (*left*) shows just part of a single, elaborately laid-out plate of food. With the scene devoid of visual clutter, it is now possible to look closely at a detail within the scene and appreciate the care and skill involved in the food's preparation and presentation.

Try for yourself

• Find a subject that is full of rich, well-defined detail.

• Take one photograph with your lens set to wide-angle, or move back so that the whole scene is visible.

• For the next shot, zoom in on some area of specific detail, or move closer to achieve the same effect You may need to adjust camera position for the best results.

● Country fair

Although there is nothing really wrong with this picture (*right*), it is impossible to see any real detail on either the horse or cart.

● Selective view

A change of view, and lens setting, has made for a far simpler, more appealing photograph (*left*). Now the eye eagerly explores the rich detail revealed on the rear of the cart seen in the shot above.

47

● Overhead view

Seen from overhead, this artist's palette makes a bright subject, full of colour, shape and texture (*below*). However, the framing is a little wide, and the inclusion of water jars, tubes, containers and the surface beyond the palette all dilute its impact somewhat.

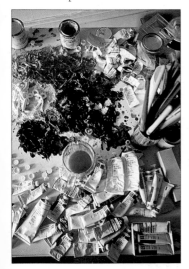

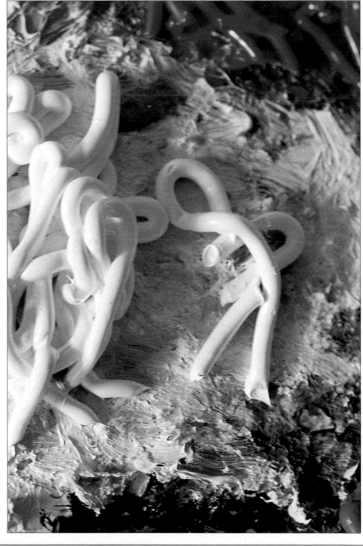

● In closer

By moving camera position just a little and then zooming in so that only the worm-like paint colours are included in the frame, the image has been simplified and strengthened. It is now the play of light, rather than the objects themselves, that dominates.

12 · Lead the viewer's eye

A well-composed photograph is often one in which the viewer's eye is led effortlessly from one part of the image to the next, until the entire subject matter has been taken in. When shooting, look for certain features in the scene – such as paths linking different parts of a view, interesting shapes created by the positions of different subject elements, or repeated colours or tones – that will help to hold, and then direct, the viewer's attention when looking at the picture.

● **S-shapes**

In this dramatically lit landscape (*right*), the unifying feature is the S-shape of the river, which leads the eye from the foreground through to the distant mountains.

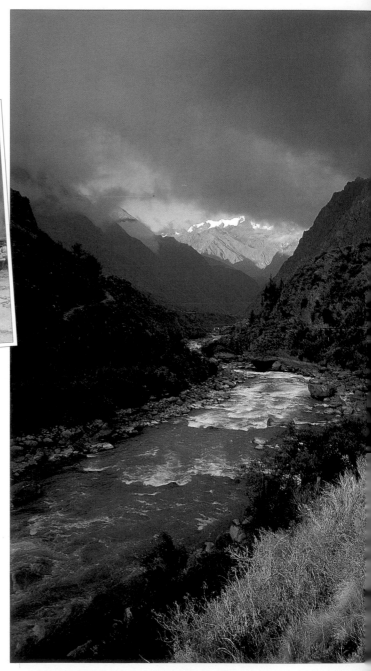

● **Triangular shapes**

A strong triangular shape has been formed here (*above*), leading up from the bicycle's front wheel to the top of the knife-grinder's head, then back to the ground.

Try for yourself

• Find a naturally occurring S-shape, such as a winding road, and take before and after pictures, changing camera positions between, so that one emphasizes and the other suppresses the shape.

• Do the same as above, taking before and after shots, but now look for diagonal lines or triangular shapes.

48

● Colour and perspective

In this photograph (*left*), the repetition of colour on the base of the building and the edge of the kerb is the main element that draws the eye into the composition. This direction has been reinforced by linear perspective, seen in the apparent convergence of parallel lines, and diminishing scale; the eye is then drawn to the people, who, although small, have great significance in the shot.

● Conflicting clues

The tunnel-like hallway (*right*) directs the eye instantly to the distant figure. This is countered, however, by the strong diagonal of the stairway, making the eye explore the whole picture area.

● Diagonal lines

Diagonal lines in a picture, such as that formed by the gondolier's pole (*below*), tend to give an image extra vitality. This, and the strong tonal differences between foreground and background, rivet the eye on the figure.

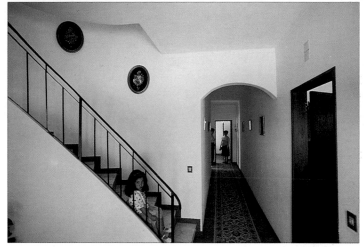

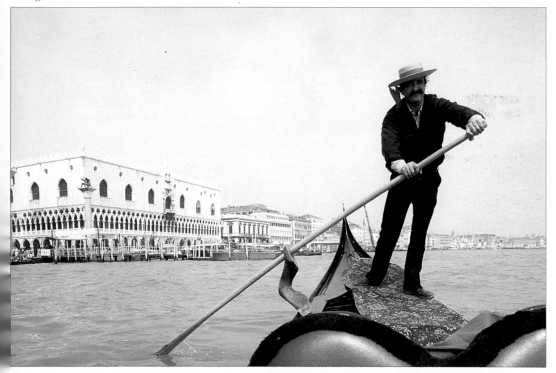

13 · Frame your shot

One of the tricks professional photographers use to heighten the impact of their photographs is to look for ways of introducing a frame within the setting – a frame within the broader picture frame. This could be something as obvious as a doorway or window, or it could be positioning the hair or arms of the model in such a way as to concentrate attention on his or her face. No matter what device you use, the object is to emphasize a particular part of the image.

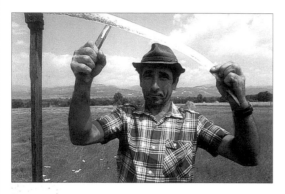

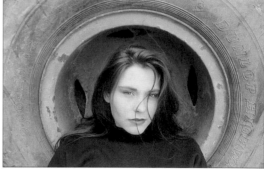

● Agricultural frame

In this picture (*above*) you can see how valuable the frame, created by the farmer's arms and scythe, has been in strengthening the subject's 'presence' in the foreground – creating a more interesting portrait.

● Window frame

Without the window frame behind this figure (*below*), the viewer's eye would not be drawn so strongly to the main subject. The reflections in the window add a feeling of lightness and depth to the image.

● Body frame

Circles make strong attractive shapes within the rectangular frame of a photograph. Here the shape is provided by a large wheel, creating a halo-like background around the portrait (*above*).

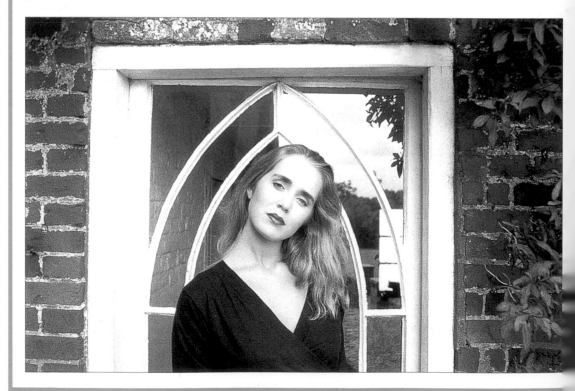

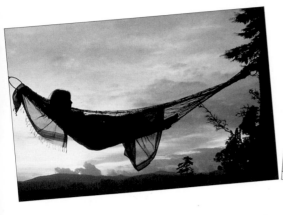

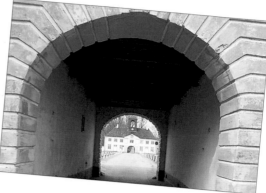

● Lighting contrast

Nature frames do not need to enclose the main subject on all sides. In this silhouetted shot of a girl resting in a hammock at sunset (*above*), the inclusion of the trees on the left and the hills at the bottom of the frame help to provide a setting for the sunset scene.

● Frames to simplify

As well as helping to define the main subject, you can use frames to simplify an image or to disguise distracting features. In this shot (*above*), the archway not only leads the eye into the picture, but obscures the cars that were parked in front of the building.

● Verandah frame

In this photograph (*right*), taken in the Romanian countryside, the frame of the verandah surrounding the house has been used very effectively to focus attention on the elderly couple. And because the man and woman have been positioned off-centre within the internal frame created by the verandah, a static composition has been avoided (*see pp. 52-3*). Another point working in the picture's favour is that the sunlight striking the surrounding woodwork helps to draw the couple forward in the picture, away from the gloomy background.

51

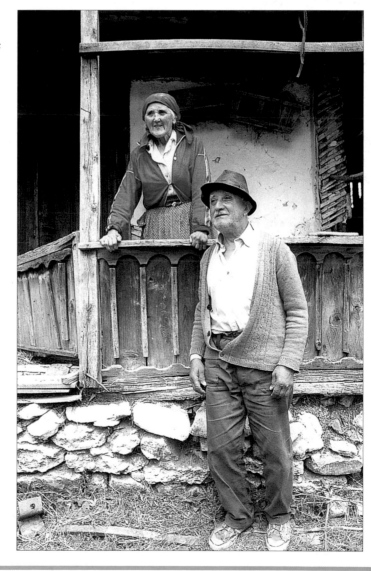

Try for yourself

• First, take a picture of a scene through an opening, making sure to include the edges of the opening – be it an arch, doorway or window – in the shot.

• Next, move your camera position and take another picture without the frame being visible. Compare the two pictures. The first, with the frame, will probably have great impact and a feeling of depth, if this device has been used correctly.

14 · Position your subject

Knowing where to position your subject within the picture space can be difficult – especially if you want to include several elements in the picture. Take time to look through the viewfinder before pressing the shutter, and pay attention to what is visible behind your main subject. You could try emphasizing some parts of the picture by finding a camera position that shows the elements at varying distances from the camera so that only some, or one, are in sharp focus.

● Off-centre – dynamic

One of the 'rules' of photography states that positioning your subject off-centre in the frame introduces an element of dynamism. In this example (*right*), the tree is about one-third in from the right-hand side of the frame and about one-third down from the top of the frame. This places it at one of the 'intersections of thirds' – points in the frame where imaginary lines dividing the picture area into thirds horizontally and vertically intersect. These intersections of thirds seem to be particularly strong in terms of image composition, so use them to emphasize specific elements of your photographs.

● Hidden in the frame

At first glance this picture looks like a still life (*left*). The scales and food make attractive shapes within the frame in the own right. It is only when the composition is studied closer that you see the chef working in the distance. As with the shot above, the man's face is positioned a third of the way down from the top, and a third of the way in from the side. This off-centre approach creates a more dynamic composition, than if the figure were placed in the centre of the frame.

Try for yourself
• Looking carefully through the camera viewfinder, position some feature of the scene on one of the intersections of thirds (*see opposite*).

• Take another shot with that same feature randomly placed in the image area and see if it seems less important as a result.

● Central position
Positioning the main subject near the centre of the frame creates a less dynamic, and more restful composition. This can suit tranquil scenes as in this portrait (*left*) and symmetrical subjects.

● Use the diagonal
Diagonals are invaluable for breaking up the scene, creating dynamic lines that refuse to run parallel with the frame. Here the line of trees (*below*), leads the eye through an otherwise restful scene.

53

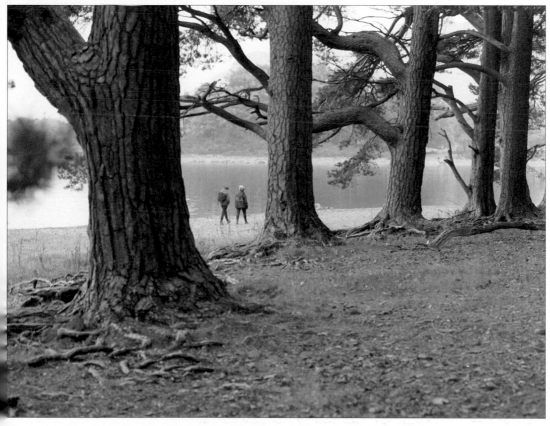

15 · Decide what to include for a portrait

All of us are aware of at least the fundamental 'rules' of taking portraits, such as not cutting off part of the subject's head or ensuring that, in a full-length portrait, the feet are not cut off at the ankles. Beyond these basic points, however, many people simply don't give any thought to how the subject looks in relation to his or her surroundings, or whether or not the framing of the figure appears natural and comfortable.

54

● Too close

Here, the subject was too close to a lens set to wide-angle (*above*). If your camera has a fixed wide-angle, take a shot from farther back and enlarge the part of the print that shows the face.

● Too cramped

Although this shot (*left*) is much better than the first version, the left-hand side is cramped, and there is an unnecessarily large area of background above the girl's head.

● Well balanced

In this version (*above*) all the elements for a good portrait have come together. The girl is well placed and dominant in the frame and enough of the background is visible to give a sense of setting.

● Bad cropping

Framing a figure so that it is cropped off at the knees (*left*) always tends to give an uncomfortable feel to shots.

● Too small

In this version (*right*) the girl has been framed full-length. However, she is now too small in the frame and the background foliage is starting to dominate the picture. Moving in closer and lowering the camera position would have made for a better composition.

Try for yourself

• Find a reasonably open setting on a light but not overly bright day. If possible, position your subject about 8 ft (2.5 m) from an attractive background of trees, foliage or something similar.

• If you have a zoom lens, you could take these three different images from the same spot, using the zoom control to alter framing.

• Alternatively, use the same lens setting and alter the distance from the subject. Take one full-length portrait, move in closer and take one half-length shot, and then move closer still for a head-and-shoulders picture.

• Before taking each picture, run through the following checklist:

1 Look carefully at all four sides of the viewfinder frame to make sure that no part of the subject has been cropped off.
2 Make sure that the camera is set to focus on the subject's eyes, since this is the part of the face that is nearly always looked at first.
3 On a sunny day, make sure the subject is not squinting.
4 Check that the background is not competing and is making a positive contribution.

● Lenses for portraits

If your camera is a single lens reflex and accepts interchangeable lenses, or you have an SLR or compact camera fitted with a zoom lens, then you have the choice of using lens focal length to determine framing (*see pp. 138-9*), as well as moving closer in or farther back from the subject.

Wide-angle

For a fun portrait (*above*) you can use a wide-angle lens or lens setting close to the subject. The type of distortion seen here is inevitable, though.

Telephoto

For a distortion-free head shot (*below*), move back and use a longer lens setting. As you can see, this still gives you the same size of image.

16 · Pose your subject for a portrait

Once you, as the photographer, start taking a hand in directing how the subject of the portrait should stand or sit, or where they should be in relation to the background, you need to have a pretty clear idea of the type of picture you are after. Most people finding this aspect of photography the most difficult, and any embarrassment or awkwardness on your part will immediately be transmitted to your subject – with the likelihood that stilted pictures will result.

● **Awkward line-up**

In this type of family portrait (*below*) you can see many problems. First, all three people look uncomfortable and stiff, almost like a police line-up, and nobody is making physical contact with anybody else. The difference in height between the mother and her two children is also a problem and the clothes line, washing and fallen bicycle all represent distracting elements.

56

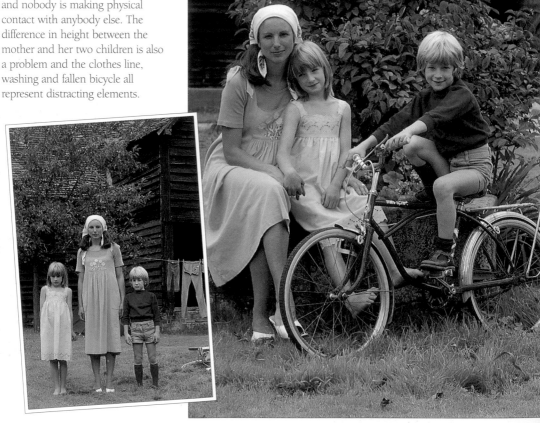

● **Relaxed pose**

In this version (*above right*) all three are at about the same level, but encouraging physical contact between mother and daughter makes for a relaxed pose. The background makes a positive contribution, as does the bicycle.

Try for yourself

• Before pressing the shutter, ask your subject to stand square-on to the camera and then turn to show each profile at about 45° to the camera. Decide which makes the best pose before shooting.

• Don't concentrate just on the subject. Make sure backgrounds are not distracting. Use a larger aperture or longer focal length, if necessary, to throw the background out of focus.

● Backgrounds

When you pose your subject in front of a strong background, the viewer may be in some confusion about which you intended to be the main subject of the photograph.

Varying the pose

These shots (*left to right*) illustrate how you can manipulate picture elements to show subject and background in different ways – sometimes one dominating the other.

57

● Cropping the image

Composition does not begin and end with the camera. Once the shot has been taken it can be recropped. An advantage of this approach is that you are not tied to the rectangular shape dictated by the viewfinder..

In the original shot (*right*), the background is interesting – but the strong triangular shape can't help but compete for the viewer's attention. Trimming the shot down on the computer screen (*above*) creates a much more traditional portrait from the picture.

17 · Alter the pose

When taking close-ups of your subjects for head-and-shoulders shots, or for full-face images, you need to pay particular attention to the subject's pose. The tilt of the head, the direction of the eyes, whether the face makes a static, square-on shape or a dynamic, diagonal composition all become more important than in half-length or full-length poses. Always take several shots, varying the pose of each, to see which suits the model best.

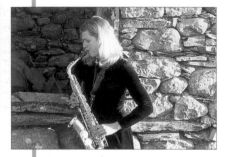

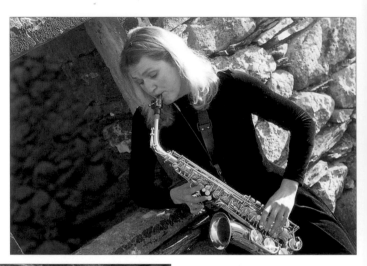

● Diagonal composition

In these pictures (*above and right*) you can see the extra 'punch' the image gains by tilting the camera to create a stronger diagonal line from the saxophone.

58

● Pose and style

How you pose your subject can have a telling effect on the mood and atmosphere of a picture. With the hair covering much of the face and angled head (*left*), the portrait looks more informal and intimate than the more traditional pose above.

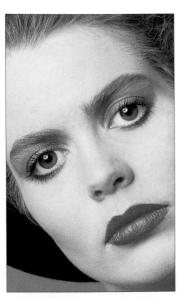

● Move in close

Remember that the camera lens can be unkind in close-up, so use a long lens or setting if possible. But if the model's face will take a really close view then dramatic results are possible. In the first shot (*left*), the diagonal composition is good. However, the face looks uncomfortably cramped and seems to be barely contained within the frame. In the next version (*right*), image magnification is about the same, but the camera has shifted to the right to cut the face in half. Immediately, this picture becomes more intriguing, and the overall effect less claustrophobic.

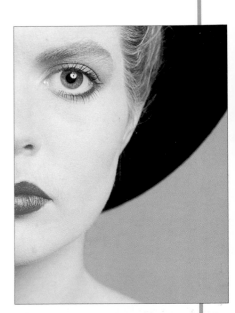

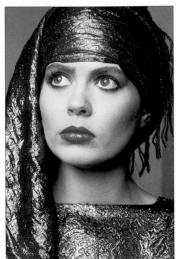

59

● Full face or profile

By comparing the full-face version (*above*) with the profile (*right*), you can see how the emphasis of the images changes from the headdress to the face itself.

Try for yourself

• Take one shot with a wide-angle setting so that the subject's face fills the frame.

• Take another from farther back using a telephoto setting, again with the face filling the frame. The difference should be startling.

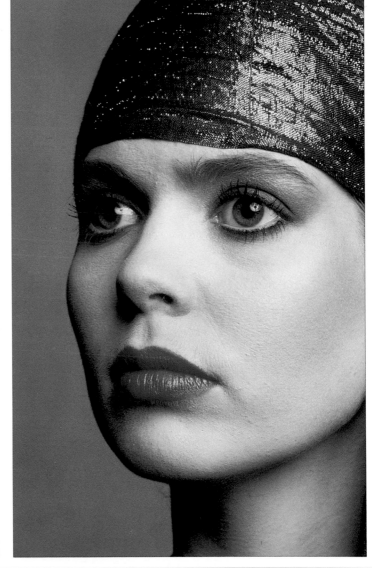

18 · Look for alternative shots

There is always more than one shot to be taken in any location or of any subject. The pictures on pages 44-5 are about moving around your subject to exploit different angles and lighting effects, while the pictures here, hopefully, will encourage you to be more imaginative in your photographic approach and actively to seek picture opportunities where others might simply walk by.

● Standard shot

This picture of a flower stall and stall keeper (*left*) is attractive, well-exposed and sensibly framed, and it is the type of photograph most people would take given this type of subject and setting.

● Alternative view

The opportunity for this second picture (*below*) arose when the stall keeper moved away from behind the stall. By zooming in from much the same camera position I had used for the first shot, I was able to turn a rather prosaic image turns into a near abstract – one that has more impact as a result. Moving closer to the subject with a non-zoom camera would give the same type of effect.

Try for yourself

• It is possible to develop the eye to start to notice unusual ways of framing the subject

• Take a subject such as a carved or pottery figure study. Ideally, it should be a detailed subject; one that is well executed from all angles.

• As a comparison, take one picture showing it in much the way it was intended to be viewed. Then take about three or four other pictures of it from alternative angles. You could try over-head shots, or move in close to focus on interesting details. Make good use of your camera viewfinder. Its hard-edged boundaries help you to visualize how the subject will look as a print.

● Isolating details

It is often tempting to tell the whole story with a single photograph. But the trouble with this approach is that you end up packing too much detail into a single frame. By zooming in, or moving closer, to isolate just a part of a scene or an individual, you create a simpler composition. These less-cluttered images often make stronger photographs.

Getting in close

Taking details is one of the ways in which that you can get different pictures of the same scene or subject. The portrait of the nun sitting with the zither makes an interesting portrait (*right*)– but once this is taken it is also worth looking for alternatives, such as a close-up of the instrument itself (*left*).

61

● Detailed view

It must be the subject itself that dictates the best framing for a photograph. The detail shown here (*above*) has more to offer as a picture than did the stained glass window as a whole.

● Overall view

With this stained glass window (*above*) it is the way in which all the colours work together that attracts attention. In this case, then, an overall view was called for rather than a detailed close-up.

19·Create a sense of movement

All of us have seen photographs of fast-moving action frozen by a brief burst of
light from a flashgun (*see pp. 64-5*) or by the photographer using a very fast
shutter speed (*see pp. 140-1*), but do these types of shots really convey a
sense of movement? As you can see from the pictures here, photographs do not
need to be pin sharp every time to work, and often a little blur due to subject or
camera movement can add an extra dimension to your work.

● Slow shutter

Looking down at this dull-coloured surface (*right*), the
camera's autoexposure system selected a shutter speed
of only ⅓₀ second. If you are careful, this is about the
slowest shutter speed that can be hand held before
camera shake becomes a problem. However, just as the
picture was taken, this child and push chair entered
the frame – and they were moving fast enough to blur.
The juxtaposing of sharp and blurred detail in the same
shot creates an unusual effect.

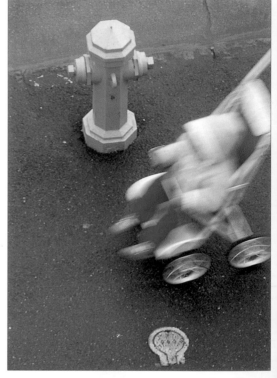

62

● Panning

If you move, or pan, the camera to keep up with a fast-
moving subject while you are taking a picture, the
subject stays in the same place in relation to the
camera, while all stationary features in the scene are
elongated into streaks (*below*). Not only does this
produce a strong sense of movement, it prevents a
cluttered or overly detailed background from taking
attention away from the main subject.

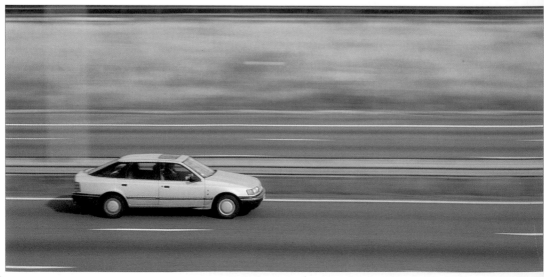

Try for yourself

• Panning is not a difficult technique to practise, and results can be very eye-catching. However, pictures are often more spectacular with the right background.

• With a subject such as a runner, cyclist or moving car, take your first picture from a slightly elevated position that shows your subject against a plain background, such as a featureless road surface or stretch of grass.

• For the next image, shoot the same subject, using the same shutter speed, against a richly detailed background, such as shop windows, parked cars or spectators at a running track. When comparing results you will see that the more detailed the background, the more attractive the streaks caused by the camera movement.

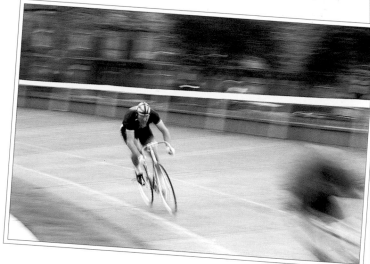

● Diagonal movement

This shot of a cyclist (*above*) was slightly panned to emphasize his diagonal movement across the frame. The farther away the subject is, however, the less you need move the camera to keep up, which is why the nearer, second cyclist at the edge of the picture seems so blurred.

● Zoom movement

Shots like this (*below*) are possible if you have a zoom lens on the camera, and they result from changing the focal length of the lens while the shutter is open. Using this zoom-movement technique you can create a sense of action and movement from even a static scene.

63

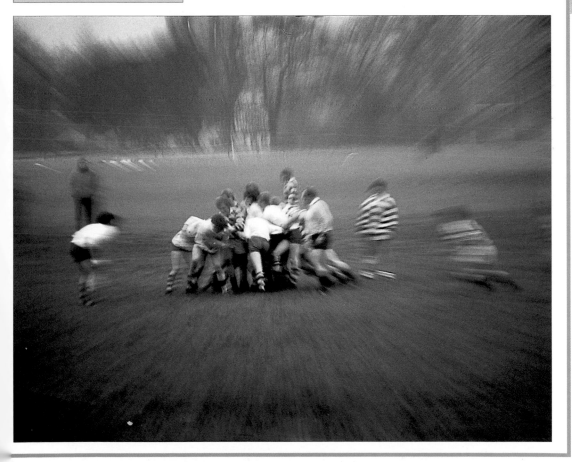

20 · Use on-camera flash

Don't expect a built-in flash, or even a small add-on unit, to solve all your lighting problems if you are shooting in a large, dimly lit space such as a church, museum or auditorium. It simply won't have the power. Instead, concentrate on small details, such as individual exhibits or architectural details within the operating range of your flash (check the instruction manual for your particular flash). And as the pictures here show, flash can be a versatile light source.

● Flash fall-off

When subjects in a picture are at a range of distances from the camera, the near ones will appear well lit while those beyond the working range of the flash will be underexposed (*right*). This effect is known as 'flash fall-off'. One way to avoid this is to position a mirror (out of sight of the camera) or some other highly reflective surface to bounce the light around the scene and increase your range a little. If this is not possible, then try to find a camera position where everybody is, more or less, the same distance from the flash.

64

Try for yourself

• Using on-camera flash, take one picture looking down, say, a long table of diners, and another broadside on to the subjects.

• In the first, those closest to the flash may be too bright and those farther away too dark. In the second, everybody will be about the same distance from the flash and exposure will be even.

● Action-stopping flash

Even a low-power flash unit delivers an extremely brief burst of light of about $\frac{1}{1000}$ sec to illuminate your picture, and $\frac{1}{10,000}$ sec is not uncommon if the subject is very close to the camera. This is easily brief enough to stop a punch at the moment of impact (*left*), as long as you have a ringside seat.

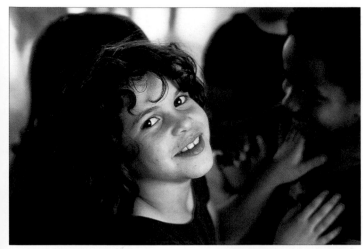

● Diffused flash

Even with weak daylight in a scene, the flash on many compact cameras automatically fires if the camera determines that light levels are too low for an ordinary picture (*left*). This may be useful if you can lower the strength of the flash to stop the lighting looking artificial. Most cameras achieve this by offering a 'fill-in light' facility (*see below*), which gives about a quarter of the output. If your camera does not have this, place one or two folds of a white handkerchief over the flash head to diffuse and soften the light.

● Flash fill-in

Light from overhead, coupled with a model in a wide-brimmed hat, is bound to throw shadows over the face (*right*). To overcome this (*below*), you need to fill in just the shadows using a light source such as flash. In this predominantly daylit scene, you need to diffuse the flash so that its light does not overwhelm the natural light (*see above*). You also may have to crouch if you are taller than your subject to ensure that the light reaches the shadows.

65

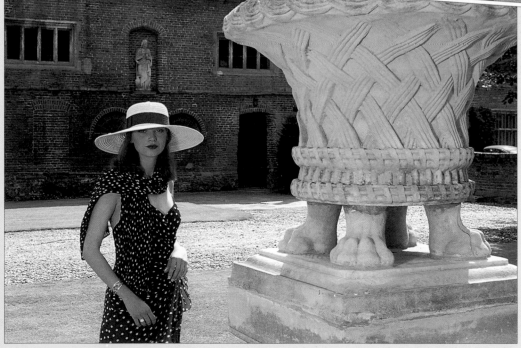

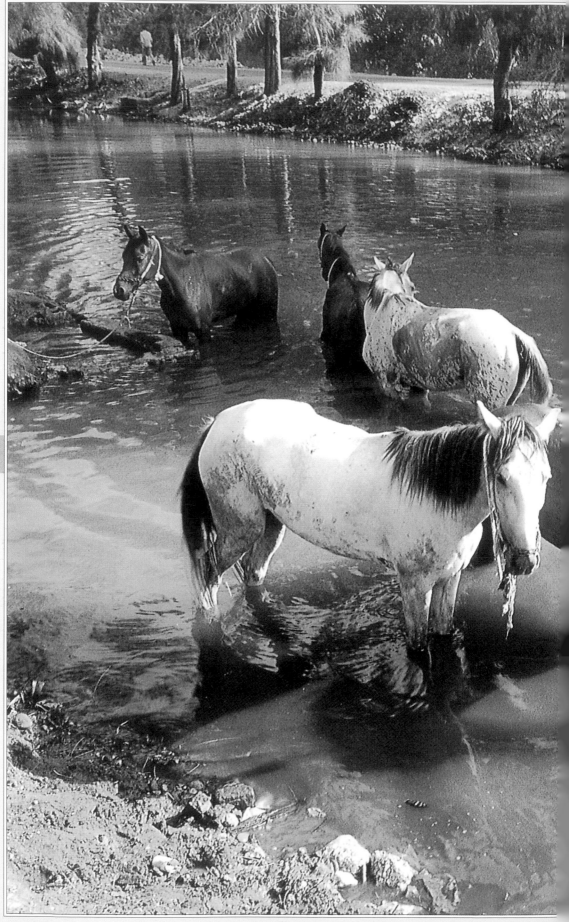

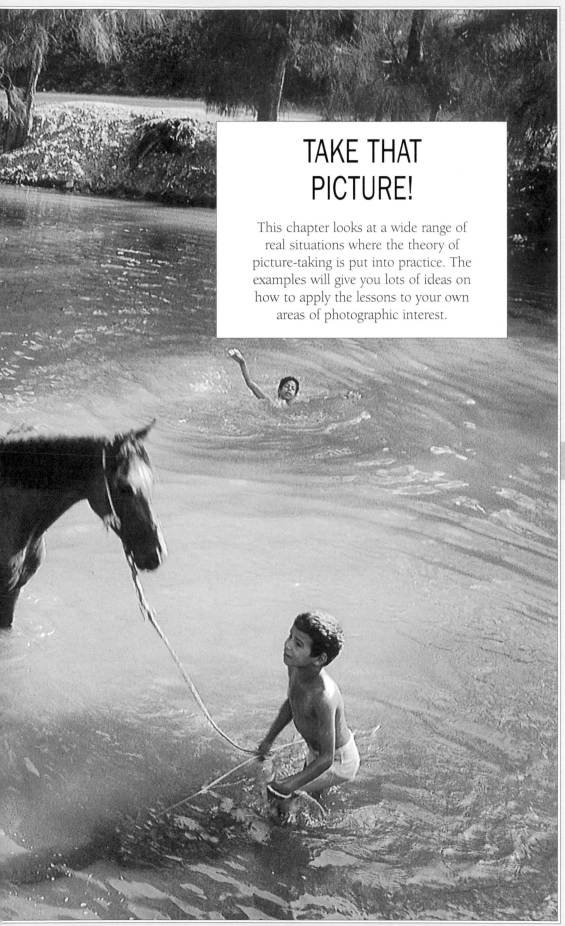

TAKE THAT PICTURE!

This chapter looks at a wide range of real situations where the theory of picture-taking is put into practice. The examples will give you lots of ideas on how to apply the lessons to your own areas of photographic interest.

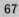

Capturing local colour

Holidays can be an exciting time for photography. For one thing, you will have more time on your hands to concentrate on taking pictures and, for another, being somewhere different tends to sharpen your perception, so you may see photo opportunities at every turn. Make sure you are familiar with your camera before leaving home, however, so that you don't have to think about what to do to get the type of shot you want, and perhaps miss it altogether.

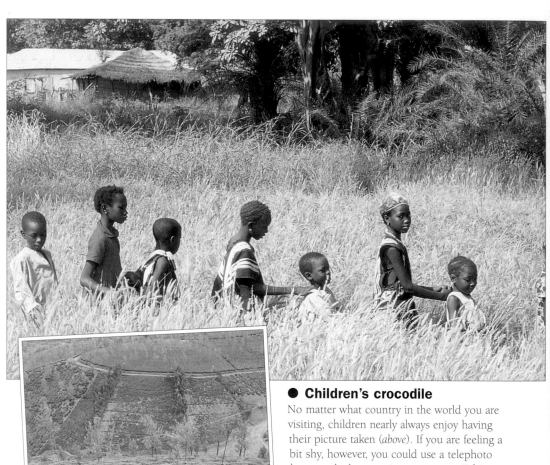

● Children's crocodile
No matter what country in the world you are visiting, children nearly always enjoy having their picture taken (*above*). If you are feeling a bit shy, however, you could use a telephoto lens or telephoto setting on a zoom. Taking this picture from a slight distance from the subjects allowed me to show the lush tropical setting of the location.

● Women at work
This picture (*left*) immediately tells the viewer that the work these women are performing is tea picking. Working in fields close to the network of access roads criss-crossing the tea-growing region in Sri Lanka, these women are well used to being the subject of photographers' attention. Even so, when a good shot presents itself you need to react quickly.

● Attitude is important

When visiting foreign countries, try to remain sensitive to the way other people may be reacting to you, and your camera's, presence. If you are open and friendly in your approach, a common language becomes less important and you are likely to enlist the active, if a little tentative, co-operation of your subjects (*above*).

● Faces that tell a story

Sometimes a photographic opportunity is literally thrust at you. These Romanian children (*below*) had been working in the fields until they noticed the camera. They then arranged themselves in this group, and insisted a picture was taken. Every face is clear and sharp and each seems to tell its own story.

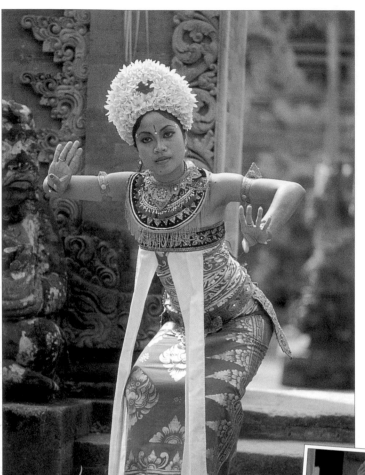

● Balinese dancer

In some holiday destinations, such as Bali in Indonesia, there is a strong tradition of both music and dance (*left*). All the hotels on Bali feature dance troupes as part of the entertainment they provide for their guests, and there are also regular performances at the schools where the dancers and musicians are taught. So, opportunity is not a problem. For this shot, a telephoto lens setting was necessary in order to isolate just a single figure, and the limited depth of sharp focus associated with telephoto lenses and settings (*see pp. 138-9*) ensures that the viewer's attention is not distracted by background elements intruding too forcefully.

● Indian snake charmer

From a tourist's point of view, what could be more characteristic of India than a snake charmer (*right*). The cobra is not really attracted by the music; it is the movement of the pipe and the rod extending towards the snake that causes it to sway as if in time to the notes being played. Payment is expected by these performers and they therefore don't mind if you squat down with the camera and take your time lining up the shot properly.

● Street posters

Part of capturing the local atmosphere of another country is being aware of the small details of life there that you wouldn't necessarily see at home. This torn and peeling street poster (*above*) is an example of the type of thing to look out for.

● Dried flowers

This display of bunches of dried flowers for sale hung on a make-shift line (*below*) makes a charming and colourful composition – the perfect type of shot to intersperse with more obvious holiday photographs if you want to give a well-rounded impression of your destination.

Useful tips

• Being on holiday is not the perfect time to experiment with a brand new camera or lens. Buy equipment well before leaving so that you have plenty of time to familiarize yourself with how it works.

• If possible, take more memory capacity (or film) than you are likely to use. Buying extra memory cards may be difficult in some locations; a portable hard drive to archive images with is an alternative (*see page 22-23*).

• The more you can read about the country you intend to visit before arriving, the more likely it is that you will not miss out on good photographic opportunities.

• Respect local customs when abroad. In some countries the intrusion of a camera could be regarded as offensive.

71

On the beach

Some precautions are essential when you take a camera on to a beach, since both sand and salt water are potentially damaging to the delicate front surface of the camera lens and to the internal workings of the camera itself. For a well-rounded series of photographs, don't concentrate just on lazing bodies slowly toasting in the sunshine. If the beach has an attractive setting, make sure to get some shots of that too, as well as any beach activities that may be going on.

● Water sports

Always try for simple images that show your subjects free of extraneous, distracting details, as in this shot (*below*). A slightly lower camera angle would have revealed the legs of bathers beyond.

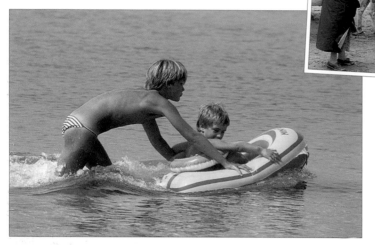

● Conflicting subjects

This picture (*above*) could be better if the ladies on the left or the girls and donkeys on the right were the only centre of interest.

● Camera height

Pictures of children are usually better if the camera is held at about their eye level (*below*).

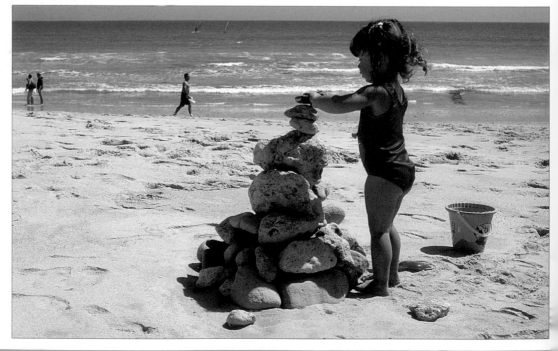

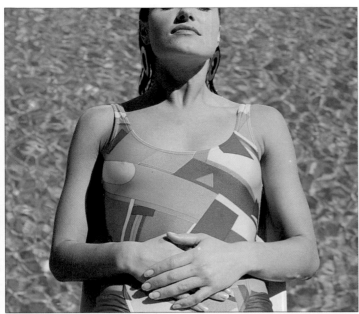

● Imaginative approach

For a different, more imaginative approach to a familiar subject, such as this girl floating on the calm surface of a beach-side pool (*left*), try showing only part of the figure. Had all of her face been visible, that would probably have become the centre of interest. In this version, however, she has become the vehicle for an exercise concentrating on colour, texture and shape.

● Tight framing

A zoom or telephoto lens allows you to frame subjects tightly from some distance away (*right*). By cropping into the sun-lounger covers, the picture has a compositional strength that would have been missing if the whole figure had been shown.

● Lens distortion

Using a slight wide-angle setting close in and shooting down on the child (*below*) has made her red face mask appear very large in the frame. The result is a good, humorous picture that breaks the rules.

73

● Bad weather

The beach takes on a different, but no less photogenic, character when the sky is overcast. Here (*left*) an empty pleasure pier is the backdrop to a beach deserted by all, except for four forlorn donkeys standing in a semi-circle around their keeper, who is slumped in a deckchair.

● Side trips

Beach resorts usually have a town nearby, and coastal towns often have a fishing fleet. The framing of this shot (*below*) ensures that the foreground, middle ground and background are full of interest.

Useful tips

• Keep camera and lens in a bag or case when not in use.

• Clean salt water off lens or camera body immediately.

• Choose special waterproof cameras or housings for use on and under the water.

● Holiday details

As well as sun and sand, children and donkey rides, a set of beach holiday photographs benefits from a change of pace and emphasis. Pictures of details, such as the type of food you would never normally eat (*above*) and trinkets you would normally never buy (*below*), all help to conjure up the atmosphere and bring back the memories.

Candid portraits

Candid portraits are pictures taken either without the knowledge of the subjects or when the subjects are completely off-guard. It is the nature of this type of photography that you never know when the opportunity for a good candid shot is likely to occur, so stay alert and be prepared to shoot quickly (point-and-shoot cameras can sometimes have the edge here). If you get time, try for a second shot, this time paying more attention to such things as framing and composition.

● Rear view

Two schoolgirls huddling under their umbrellas as they make their way back home create a charming picture. There is no need to see the girls' faces to help understand this scene – making it a much simpler picture to capture candidly.

● Shoot from the hip

For this type of shot (*left*), raising the camera to your eye might draw attention and alert the subject – and you would then lose the thoughtful pose. Instead, try resting the camera on a table, or shoot from the hip, without looking through the viewfinder. A long telephoto lens setting may also be helpful.

Useful tips

• A telephoto lens or lens setting allows you take candids of distant people without intruding on or influencing the scene.

• A fully automatic camera is quick to use and makes good candids more likely.

● Men at work

This type of situation is ideal for candids (*above*). If concentrating on their work, people are less likely to notice the camera, or change behaviour because of your presence.

● Double trouble

Catching a group of people unawares is much more difficult than shooting a candid of just one. In this shot one of the boys is looking at the camera – but the shot is still effective. The fact that the boy on the left is facing away from us adjusting his hat makes a much more charming portrait of the pair than if both had been standing in line for the lens; it presents 'real life' rather than a photographic pose.

Children

Within the family, children are probably the most popular subject for the camera. They change so rapidly over the years that they are a constant source of new inspiration. And if you are not particularly confident when using a camera, then children make ideal subjects, since they nearly always want to be included and so make willing participants in the exercise.

● Stressing movement

Children seem to possess an unending stream of energy and are always on the move. The sense of movement and activity in this shot of a toddler coming down a long slide (*right*), is emphasized and stressed by the strong vertical lines of the dividers separating the different lanes of the slide.

● Planned activity

At an event such as a ballet class (*above*) you will probably have time to take a measured, thoughtfully composed picture. The pose of the young dancer was held long enough for there to be no blurring of the image.

Useful tips

• If you want unposed, natural shots of children, wait until they have grown used to the presence of the camera before taking your photographs.

• A telephoto lens setting is ideal for taking candid pictures of children.

• For a formal picture session, make sure you have plenty of props, such as books or toys, depending on their ages, to keep them amused.

• For natural shots of young children and babies, get the camera down low to their eye level.

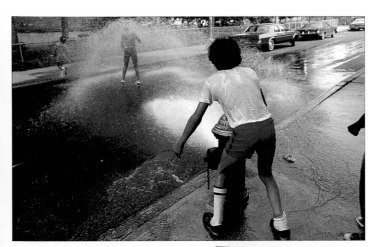

● Unplanned activity

If you always take your camera with you then you will be able to take advantage of situations such as this (*left*), which could not be planned for in advance. The boys playing with the water from the fire hydrant were so absorbed in their own fun that they failed to notice the camera at all. But these moments can be over as quickly as they start, so grab your first shot quickly and, if there is time, then try for a more considered one.

● Funfairs

Venues such as funfairs and theme parks are designed to encourage children to let their hair down, and so they should provide you with plenty of photo opportunities.

Theme pictures

Inflatables such as the ones shown here (*right and below*) are a common sight at all funfairs. They are so colourful that you could use them as a basis for a series of theme pictures (*see pp. 114-115*).

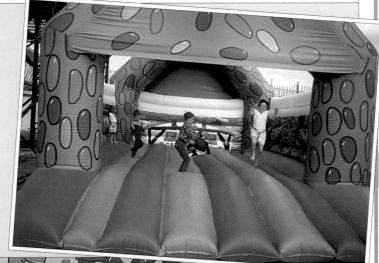

● Party time

A child's birthday party is perfect for marking an anniversary as well as providing an opportunity for some great photographs. You will probably use more film than you first think, so have plenty on hand.

Watch the watchers

At parties don't just pay attention to the birthday child or to the entertainer. Great shots can be had by zooming in on the reactions of others (*above*).

Loose framing

Resist the temptation to crop in close with every portrait. Sometimes by moving back or using a wider lens setting, you can give a better idea of a child's size, or show interesting surroundings. Here (*above*) the loose framing allows the composition to take full advantage of the fascinating shape created by the twisting playground tunnel.

A change of pace

At a child's party, quiet moments may be quite rare, so quickly grab any opportunities that present themselves (*left*).

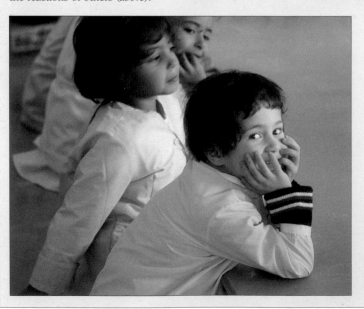

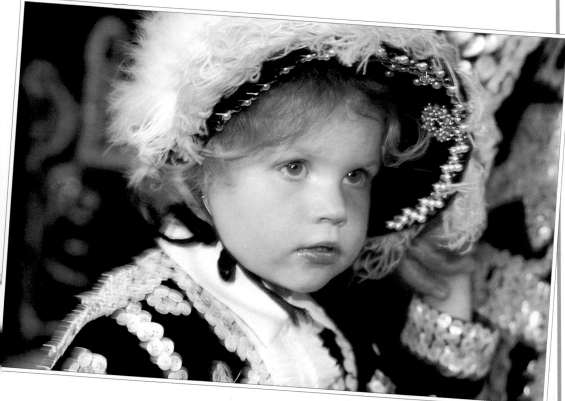

● Dressing up

Books and toys can be useful to keep children amused during a photo session, as can a box of dressing-up clothes. This little girl (*above*), however, is the youngest generation of a long line of Pearly Kings and Queens, and her button-festooned costume and bonnet are very traditional.

● Telephoto candids

When you don't want to intrude the camera on a scene for fear of spoiling it, then a telephoto lens or setting used from a distance may be the perfect solution. For this shot (*below*), a 90mm lens setting was used to record a look of rapt attention.

Informal portraits

It is not very often you set out with the intention of taking a series of informal portraits – usually it just happens that way out of chance occurrences. If, for example, you were to see a character with a good face or somebody else in a colourful costume, it is worth taking a chance and asking if they would mind if you took some photographs of them. The location, however, may not be ideal, so be selective in your framing and make the best out of the opportunity.

● Bikers

It is a pretty safe bet that if people dress in this fashion (*right*), then they are unlikely to object to being photographed. There is definitely something of the showman in both of these characters. This first picture is perhaps a little rushed, and the framing of the man in the wheelchair is too tight, giving an uncomfortable feel to the image.

82

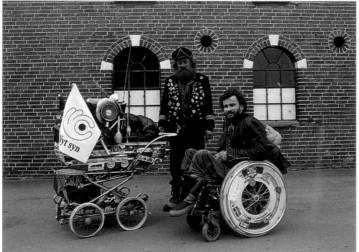

● Wider view
In this version (*above*) a wider view results in a better composition. Although the figures can't be seen in the same detail as before, the image now has balance, and including their laden and decorated pram gives extra interest. Framing the figures between the windows was important here.

● Vertical view
Turning the camera around (*see pp. 40-1*) gives a new feel to the composition (*above*). A trick of perspective associated with wide-angle lenses or settings exaggerates the distance between the two figures, but the pram is useful once again, this time acting as a link or bridge between the pair.

● Close-up

Framing your subject in a variety of ways ensures that you will be happy with at least some of your results. This close-up (*left*) was taken with the lens, at a moderate wide-angle setting only, deliberately too close to the face and slight distortion results.

● Backgrounds

Even an unpromising background can be made to work to your advantage. In this version (*above*) the military-type interpretation of the subject's garb made the strident and strictly regimented pattern of bricks and mortar seem somehow appropriate.

● A change of pose

In the same way as varying the subject's framing is important, so too is varying your subject's pose. In order to exploit a new background, this photograph (*right*) shows the biker sitting cross-legged on the floor. Framing is purposely tight at both the bottom and right-hand side of the image area in order to prevent distracting detail, which is just out of shot, from appearing. The pram has also been used to break up the large, reflective area of white, which would otherwise attract too much attention.

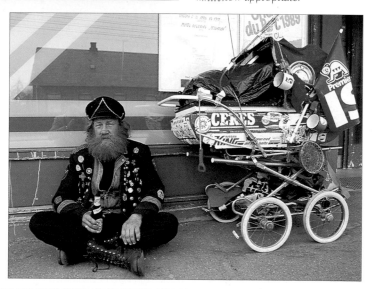

Formal portraits

When taking a formal portrait of somebody, you will normally have the time to choose settings or backgrounds – unlike taking informal portraits (*see pp.82-3*). Arrangements don't need to be elaborate, however. These could consist of perhaps nothing more than agreeing the most suitable location and a convenient time. Formal portraits most certainly do not have to be formal in the sense of conventional, stiff or straight-faced, as the pictures here illustrate.

● Make-shift studio

For this amusing image (*right*) a living room was temporarily converted into a studio. The background consists of a roll of coloured paper, and lighting came from weak fill-in flash combined with a main off-camera flash to the left of the frame. The cards were fixed in position by wire struts.

● Props

The formal attire of pianist Alfred Brendel, linked with the use of the piano as a 'prop', all set within what appears to be part of an auditorium, come together to tell us something of the man's occupation, and also lead us to assume all manner of things about his lifestyle, manner and attitudes.

Useful tips

• The more of a relationship you can strike up with your subject, the better your chances of producing a truly revealing photograph.

• If you intend to use any props, such as clothes, setting, furniture or tools, make certain they are relevant to the subject concerned and are not just decoration.

• If you want to shoot indoors, then try to use the subject's own home, since this will be full of revealing details about him or her.

• If using window light alone indoors to illuminate the subject, then make sure that parts of the picture area farthest from the window are not too heavily in shadow. If so, use a reflector.

● Clothes and setting

By having your subjects dress in a particular way for a portrait photograph you are not necessarily creating a false impression. In this portrait (*left*) the colourful shirt worn by the artist helps create a stronger link between the subject and the sculpture in the background.

● Telling a story

By taking a formal portrait you are trying to show in the photograph something more than a simple likeness of the subject – you should also aim to imply something about that person's character or nature, perhaps, or their occupation or hobby. This may put the onus on you to direct your subject, in order to achieve this story-telling objective.

Garden setting

This man (*right*) had been a professional gardener for more than 60 years, so it seemed only appropriate to show him in a garden setting holding the tools and produce of his trade.

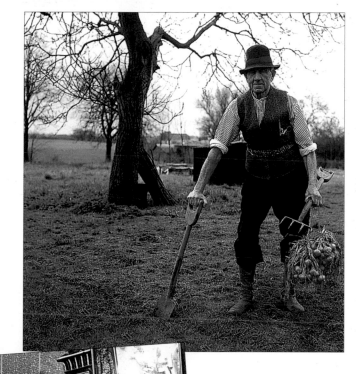

Café interior

This scene, shot inside a family-run café in Cairo (*left*), is full of revealing details about the subjects. The existing light used for the picture was not bright, making a fast ISO setting essential (*see pp. 18-19*). Even so, a hand-held shutter speed of ⅓₀ second has recorded the one moving figure heavily blurred.

Weddings

Weddings fall into two obvious parts – the ceremony and the reception – and for complete coverage you should aim to take some photographs at each, if possible. Your aim here is relatively easy to achieve, since weddings consist largely of set-pieces. Not to be missed are the couple at the alter (or equivalent), rice and confetti throwing afterwards, leaving for the reception, the speeches, cutting the cake, and the newly weds' departure for their honeymoon.

● Preparations

The set-pieces described above are the obvious shots – the public highlights, if you like. If you know the couple well, however, you have a chance to capture more personal, intimate photographs, such as this picture (*right*). Here we see the bride taking her last chance that day for a little quiet introspection before leaving for the ceremony. The composition is simple, leaving the bride firmly as the centre of interest, and the light generally soft and muted, except for the comforting hint of sunshine streaming in through the windows.

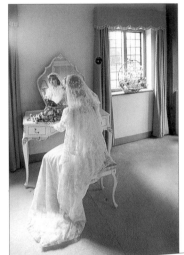

● Use the setting

Weddings take place in all manner of buildings, and each will have something to offer photographically if you really look. Some locations, of course, simply ooze photographic potential, such as this moated, high-towered chateau (*below*). But no matter what situation you find, try to make the most of the setting. As in many situations, it is attention to the details that often makes your shots work – with a veil like the one worn here, arrange it so that it becomes a positive asset to the shot.

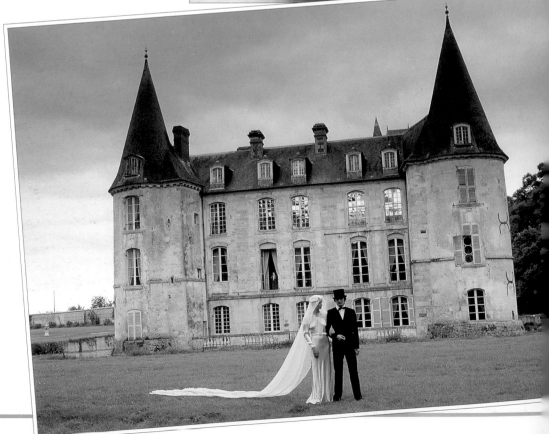

● Guests

Events such as weddings often bring far-flung families back together again, if only briefly. Take the opportunities that arise to snap as many pictures as you can of the guests outside the church, or equivalent, and at the reception. In this photograph (*right*), the poses are happy and relaxed, and the warmth of the sunshine seems to come off the page at you. A white tablecloth is also useful, since light is reflected upwards from it into the faces, filling in the shadows.

● Lucky shots

Being at the right place at the right time is always important. This amusing candid shot (*left*) shows an usher carrying a wonderful, three-tiered wedding cake so that it obscures his face. What we can see too, however, is that he is perilously close to the top of a flight of stairs. The exposure here is lucky, too, since it shows the white-suited usher and cake starkly against a dark background.

Useful tips

• As well as shooting the obvious set-pieces, keep alert to any action or amusing events that may be happening on the sidelines.

• At weddings you usually end up taking more photographs than you had planned. So, always take plenty of memory or film.

• Use a high ISO setting or film (*see pp. 18-19*) for use indoors where the light is dimmer and flash not suitable.

• If a pro photographer has been commissioned to cover the wedding, try not to get in the way while taking your own shots. Remember, that person is trying to earn a living.

Landscapes

In most cases, you will improve your landscape pictures by ensuring that there is something visually interesting in the foreground. To fit as much of the scene as possible into the picture, most people use a wide-angle lens. In the resulting pictures, everything is so small and far away that it lacks any scale and impact. The secret is to try to find things to include in the frame that will help fill the foreground and provide a focal point for the picture

● Sidelighting

Sidelighting is useful for accentuating form and texture within a landscape scene – and often provides a more challenging subject than simply standing with the sun behind you. With the sun to the side in this shot (*right*), the rounded three-dimensional shapes of the castle's turrets are highlighted.

● Early start

Landscapes often look at their best just after dawn when the sun is low in the sky, and the earth's surface is only just beginning to heat up (*below*).

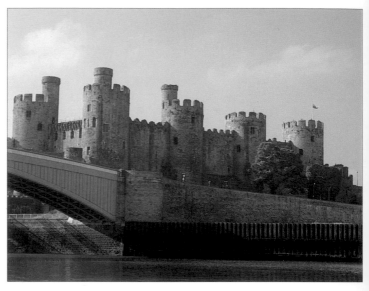

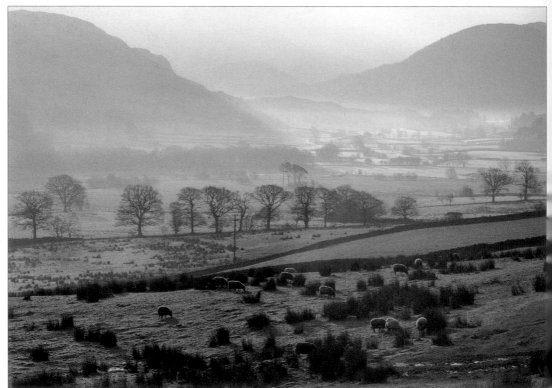

88

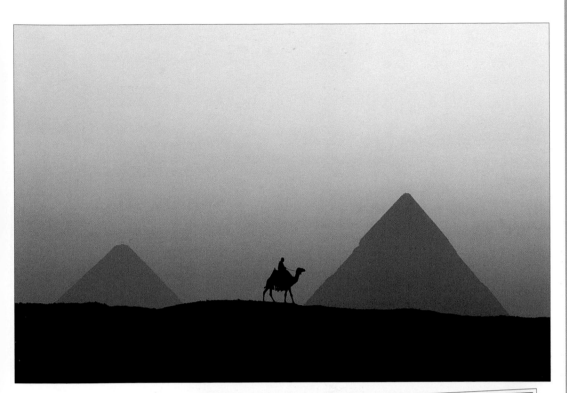

● Shape

The magnificent pyramids just outside Cairo can look ill-defined and dilapidated in normal light. Seen like this, however (*above*), silhouetted against a twilight-tinted sky, the power and majesty of their shape dominates. And to provide a sense of scale and setting, what could be better than the outline of a camel and driver caught perfectly on the high ridge of a sand dune?

● Placing the horizon

When the sky is as full of interest and colour as this (*above*), place the horizon lower down in the camera viewfinder and let it dominate the landscape beneath. The tree on the left is useful in providing foreground interest.

● Evening sun

The last rays of the evening sun reflect from this house window (*left*) to provide a splash of colour in a composition of skeletal trees seen against a darkening sky.

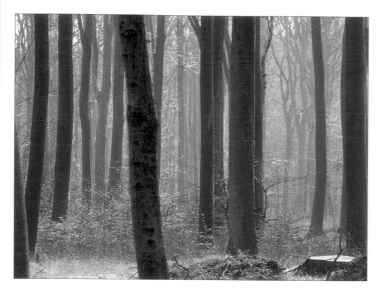

● Subject planes

One of the most difficult aspects of landscape photography is seeing which area of the scene to isolate with the lens. In this picture (*right*) the clearly defined foreground, middle ground and background mean a wide-angle approach works successfully. Stretches of water are invaluable to the photographer, as they double the the amount of detail or colour in a scene.

Useful tips

• It is usually best to use a slow ISO setting (*see pp. 18-19*) for landscapes in order to record fine detail.

• Light may change the appearance of a landscape minute by minute, so stay alert to interesting lighting fluctuations.

• If the sky is full of cloud and colour, try lowering the horizon in the picture so that the sky takes up more of the image area

● Repeating pattern

By concentrating on just one element in a landscape, such as shape or pattern (*above*), you can create a photograph that says much more about a scene than one that shows too much, potentially distracting, detail. The slight grey-blue colour of the background is an atmospheric effect known to photographers as aerial perspective (*see pp. 38-9*).

● Using exposure

Simple images often have an impact that more complex ones do not. In this picture (*below*), the subject has been reduced to eerie, white shapes floating out of the background gloom. This result was achieved by taking a close-up exposure reading from the white bark, locking the reading into the camera, and then moving back to recompose the picture before shooting.

90

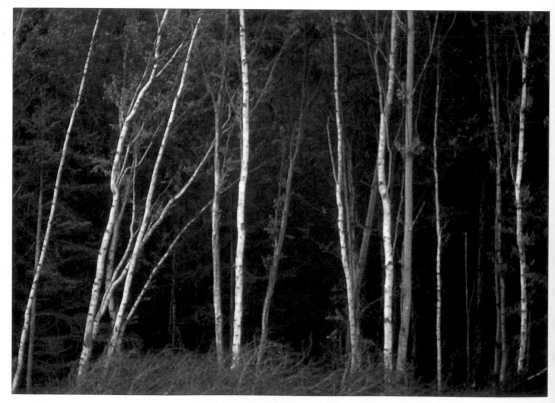

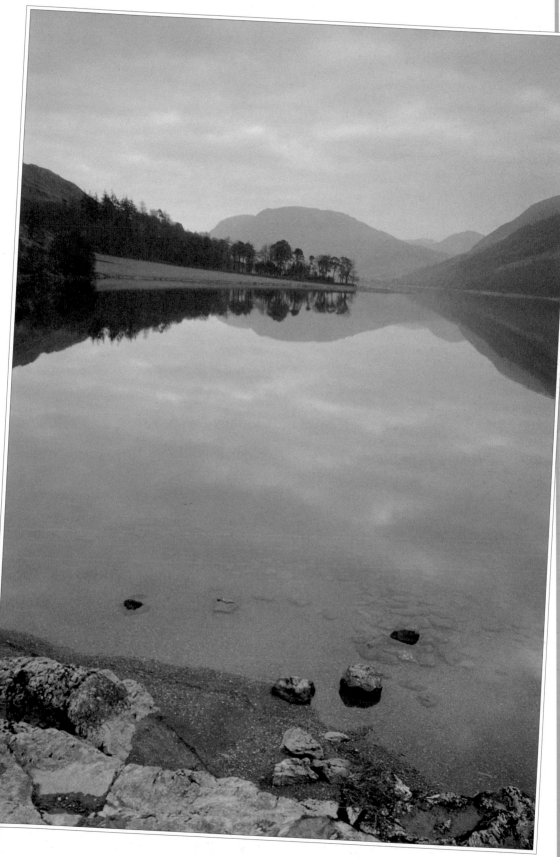

Plants and gardens

The infinite variety of shape, colour, texture and form to be found in plants and their garden settings make them fascinating subjects. Since you can approach this subject in so many ways, virtually any type of camera and lens combination will be satisfactory. Your principal light source will be the sun, so make sure to use the different qualities of light as the sun moves through the sky.

● Restricted view

The fresh green of early spring foliage and an underplanting of bluebells make an idyllic wood-land setting (*above*). The view of the lens has restricted the colour range to these two colours, and thus heightened their impact.

● Texture

Light coming in from the side of this fresh, young foliage (*left*) has helped to accentuate the texture of its ribbed surface (*see pp. 34-5*). The other foliage is darker in tone and so does not compete for the viewer's attention.

● Garden details

This stylishly elegant garden bench (*right*) implies much about the garden as a whole. The camera angle has been kept low so that all of the sky is excluded from the frame. This strengthens the lighting contrast between the white bench and the darker hedge surrounding it.

● Isolated colour

A sheet of blue paper isolates this red hibiscus flower (*left*) from a cluttered background.

If you can't change the lens aperture to throw a background out of focus, choose a mono-chromatic background, such as this ancient tree trunk (*right*), to act as a neutral foil for the coloured blooms.

The delicate pink coloration of these geraniums (*below*) has been emphasized by a sympathetic background of weathered stone and wood.

93

Waterscapes

The placid calm of a sheltered lake or the crashing turbulence of a waterfall are just two of the opportunities you have to take photographs featuring water as the main subject. There is plenty of scope for interpretation here, perhaps by using a brief shutter speed to freeze rapidly flowing water or a long shutter speed to show it in a novel way. At night, too, water appears different, although you will need a tripod or other support if you are using very long shutter speeds.

● Water at night
In this dusk view (*right*), clouds still show colour from the sun, which is just below the horizon behind the trees. In the middle ground, lights are already on and a manually timed shutter speed was used with the camera supported on a tripod.

● Eerie stillness
The haziness of the light and the dead calm of the water (*below*) have an eerie quality that seems to herald an on-coming storm.

94

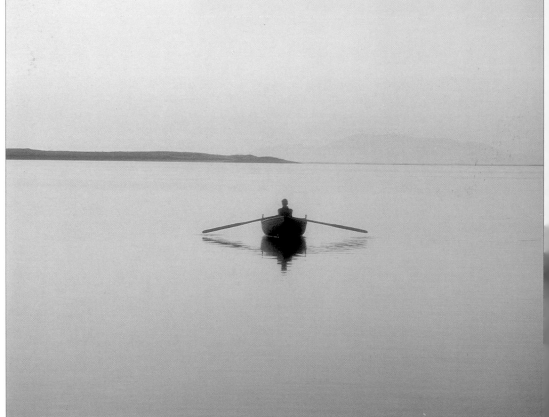

● Interpretation

If moving water features prominently in your photograph, you may find that you have quite a lot of flexibility in how you interpret it. If you have control over shutter speeds, then select a brief speed to freeze it as a mass of individual droplets. A very slow shutter speed, however, produces more unusual imagery.

Shutter speed and framing

In these images of a waterfall you can see that using a shutter speed of $\frac{1}{15}$ second has caused the fast-moving water to streak and blur, taking on a cotton-wool appearance quite unlike the way we normally think of water. Framing variations change the emphasis, too, sometimes with the waterfall dominating, sometimes the setting and foliage.

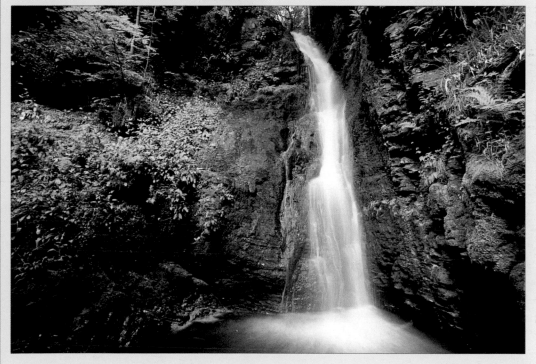

Useful tips

• If you are worried about your camera getting wet, wrap it in a plastic bag with a hole cut for the lens to poke through.

• For long exposures in daylight you may need a neutral density filter to prevent the film over-exposing. Neutral density filters are available in different strengths and can be used in combination for exposures of many seconds.

• To freeze fast-moving water you will need to select a shutter speed of about $\frac{1}{250}$ second. If this is not possible, then frame the shot so that the water is smaller in the viewfinder and then shutter speed will not be so critical.

• Water tends to take on the colour of its surroundings, appearing green, for example, if illuminated by light filtering through foliage.

Skyscapes

All too often, photographers think of the sky simply as 'that area at the top of the picture'. As you can see from the examples here, however, the sky can be an important part of a picture, changing the mood and atmosphere of the land beneath or, indeed, acting as the principal subject of the shot. Usually, the sky is much brighter than any other part of a picture, so if your camera measures exposure from it, the rest of the scene may appear dark and underexposed.

● Stormy skies

When the wind builds in strength, piling the clouds up into billowing masses and heralding an on-coming storm, don't pack your camera away. This is when skies can be at their most dramatic, and the quality and appearance of light can change from minute to minute (*see p. 102*). In this shot (*right*), turning the camera on its side for a vertical shot made it possible to take in a large area of mottled grey, threatening sky, while also including the intensely deep, saturated greens of the landscape beneath.

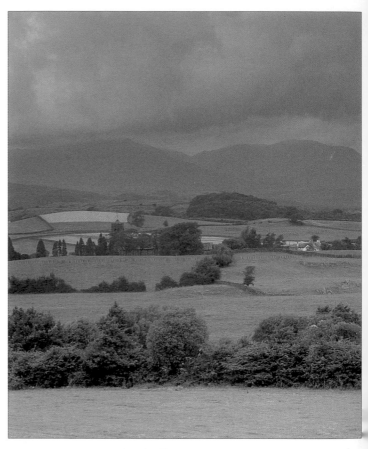

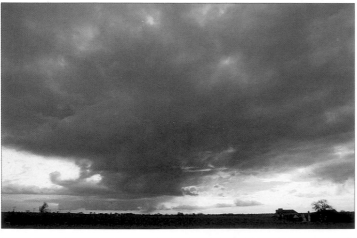

● Exposure

Look for interesting cloud formations (*left*) if you intend to make the sky the subject of a photograph. In a situation like this, allow the sky to take up most of the picture area – a thin strip of land at the bottom of the frame is sufficient. Because the camera exposes for the sky, any land areas are likely to be underexposed. But as you can see, this can add to the impact of your picture, with features starkly silhouetted on the horizon.

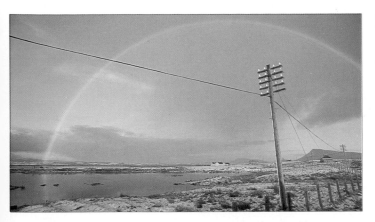

• Whenever bright sun appears in the viewfinder you must take great care not to damage your eyes. This is especially important if you are using a telephoto lens or the telephoto end of a zoom lens, since the sun then appears to be so much larger and therefore brighter.

• If the sky is so bright that the camera is signalling likely overexposure, you can fit a neutral density filter over the lens. This grey filter lessens the amount of light entering the camera overall without affecting subject colour.

● Rainbow

Rainbows (*above*) occur when sunlight shines through raindrops before reaching you. Each drop acts as a prism, splitting the light into the colours of the spectrum.

● Evening skies

When the sun is below the horizon, for some time light is seen reflecting from the underside of clouds (*below*), and the effect can be spectacular.

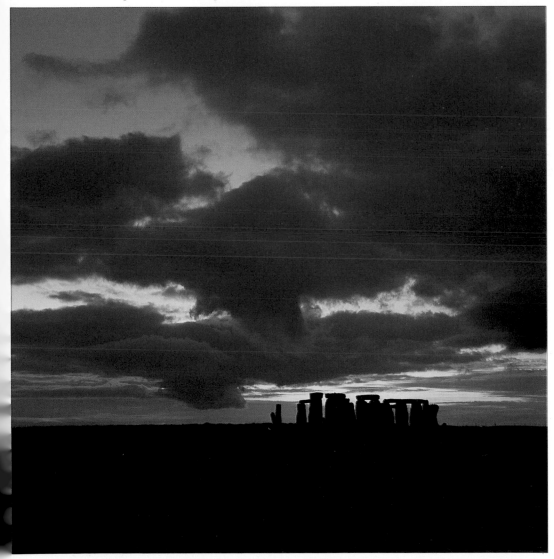

Animals and plants

To photograph animals in their natural surroundings it helps to have a long telephoto lens in order to get in close. A 300mm is a good start, but the exact focal length will depend on the creature's size, timidity or ferociousness.. But even with a moderate zoom, you will still be able to find subjects in your own garden or local park. Animals in these settings are often less timid and will allow you to approach reasonably close. Other good locations for animal shots are safari parks, farms and zoos.

● Tree fungus

This type of fungus is commonly found on dead wood and makes a strikingly beautiful subject for the camera (*left*). The gloomy light of the forest floor has helped intensify the subject's colours.

● Tank fish

To take this type of shot (*below*) you have to light the tank from above to stop the flash reflecting back off the glass aquarium.

● Telephoto setting

By using the telephoto lens setting on a compact camera (*above*), the depth of field (*see pp. 138-9*) is so shallow that the monkey is the only part of the image in sharp focus.

● Garden birds

Garden birds, such as this thrush (*right*), can become quite tame in winter and allow you to approach cautiously with a camera.

Useful tips

• The closer the camera lens is to the bars or wires of an animal enclosure, the more out of focus they appear on the print, and so the less they intrude.

• Leave food out in the same spot in your garden and at the same time of day to attract animals into range of your camera.

• The more you know about the behaviour of your animal subjects, the better you will be able to anticipate where they might be found.

• If photographing wild animals, then take particular care not to disturb parent animals while they are caring for their young.

● Zoo birds

A bird such as a macaw (*left*) can be more than 4ft (1.2m) long – sufficiently large for a good sized image with a mid-range 50mm zoom setting used up close.

● Park setting

Peacocks (*above*) can sometimes be found wandering freely in public parks. These large, brilliantly plumaged birds make ideal animal subjects for the camera.

● Domestic livestock

This domestic rooster (*right*) is as lovely a subject as you will find in the wild, and it will be used to people so that you can approach as close as you like.

Times of day

The time you choose to take a picture has a profound effect on its appearance, for it is not only the strength of light that changes throughout the day, but also its colour. At dawn and towards dusk the sun is low in the sky and the light tends to produce a softer, redder type of image. In the late morning through to early afternoon, the sun is high in the sky and colours tend to be bluer – and the difference between shadows and highlights is also more pronounced.

● Early morning
In this photograph (*left*), shot not long after dawn, a heavy mist still clings to the sides of the hills. As the sun gains strength, this will soon be burned off to leave a more well-defined landscape. Note, too, the orange warmth of the colours and the way in which the fields seem to glow in the early morning light. Much detail is still shrouded in shadows, however, but this also helps to evoke a fairy-tale image, one full of mystery and promise.

● Localized highlights
Looking at these Egyptian figures and hieroglyphs (*right*), you can see how much better defined the reliefs become when illuminated by a strong shaft of light. Those not at an oblique angle to the sun are not nearly as pronounced as the others. The central figure of Khnum, thought by the ancient Egyptians to be the lord of creation, however, is spotlit by the harsh midday sun and the highlights and shadows of this figure are more obvious and dramatic.

● Harsh light
One of the characteristics of a high, bright sun, such as you see around noon, is that colours become very intense and saturated. In this shot (*left*), the red of the drink is almost startling in coloration, while the shirt of the figure is mostly in shadow and is so deeply black that no detail can be seen at all.

● Late afternoon

As the sun travels westward and starts to dip towards the horizon in the afternoon, so shadows start to lengthen and the difference between highlights and shadows starts to lessen (*left*). Although the shadows on the unlit surfaces in this photograph are deep, they are not impenetrable and some details remain clearly visible.

● Dusk

In this dusk shot of Hong Kong harbour (*below*) there is still enough general light to make a hand-held exposure possible, yet it is dark enough for the lights around the floating restaurant to be switched on, casting a festive spell over the scene. An added bonus here is the reflection of the lights in the water.

101

The changing light

Not only does daylight change in character from dawn to dusk
(*see pp. 100-1*), it also produces a great range of different results depending
on the direction and angle at which it strikes the subject. As you can see from the
pictures here, sidelighting may produce lit and shadowy surfaces in the same subject,
while backlighting tends to give extreme, contrasty results. Frontlighting produces the
most even, descriptive light of all.

● Early morning
The rising sun and mountain mist
(*above*) create an atmospheric
backdrop for a shot of a stone
circle. At this time, daylight is soft
and, with the sun low in the sky,
the subtle ripples of the landscape
are highlighted in a way that they
would not be at other times of day.

● Sidelighting
The appearance of colour and form
depends on the lighting.
Sidelighting (*left*) makes the stones
appear more three-dimensional
than they do in the backlit images,
opposite and above.

Useful tips

• Use the backlight-compensation button found on many modern automatic compacts and SLRs to avoid turning your subject into a silhouette when the sun is behind the subject.

• On a manual camera, move in for a close-up light reading from the subject, and set this on the controls before re-composing the picture.

• If sky colour is important, a polarizing filter (*see p. 143*) over the lens may help to intensify its blue colour and strengthen the contrast between the sky and clouds.

● Frontal lighting

If you place yourself with the sun directly behind the camera position, then your subject will be frontally lit (*above*). Colours now look more uniformly saturated, and the intense blue of the sky behind the landscape creates the perfect backdrop. Frontal light fills in the shadow areas that would be formed by sidelighting (*see opposite*), and colours now seem much brighter.

● Backlighting

Backlighting occurs when the subject is between the sun and the camera position (*left*). If the image is exposed for the background, the subject becomes a dark silhouette – showing the shape of the stones alone.

Shafts of light

There is nothing as uncertain as the weather. Yet it is the weather – full sunshine, dappled daylight, storm clouds or, as has been exploited in the pictures here, shafts of light – that adds mood and atmosphere to your pictures. Many times you will come across a scene that, at first sight, seems to have little to offer. Suddenly, though, the clouds will reform or the sun move just a little, to produce a limited band of intense illumination, perfect for those with quick reflexes.

● Spotlight

High sunlight streaming through a window in the roof (*left*) has produced a beam that shines across the café scene. This not only illuminates the room, and one customer in particular, it also becomes a key part of the composition in its own right.

● Channel of light

In this forest scene, much of the frame is in darkness (*below*) – only areas that can be lit directly from above are rescued from the shadows. The lit path leading the way to the two silhouetted figures creates the basis for a successful composition.

Useful tips

• If you are confronted with a scene consisting of brightly lit surfaces and ones in deep shadow, as is typical when shafts of light feature, then you may, if your camera permits, have to take a light reading from either the shadows or highlights alone and then lock that reading into the camera. Digital image sensors (or film) often cannot cope with extremes of lighting contrast.

If the light reading is taken for the shadow areas of a scene, then the highlights will 'burn out', seeming to expand slightly into the edges of the surrounding shadows. A reading taken from the highlights will cause shadow areas to deepen, and they may become impenetrable.

104

● Reflective surfaces

Acting like a mirror, the reflective surfaces of the boat (*above*) glow out of the muted colours and tones of this riverside scene. With very directional light like this, you may have only seconds to take your photograph before the light changes and the magic evaporates.

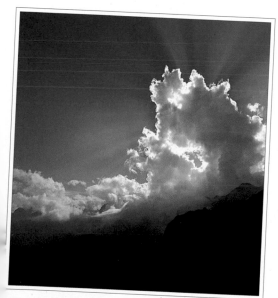

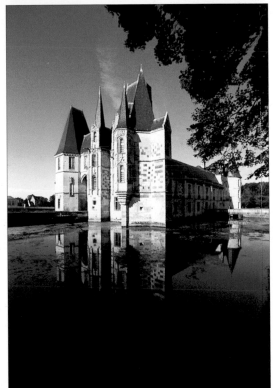

● Cloudscape

Rays of the sun (*above*) become visible like this when the air is full of particles, such as dust, and the light source itself is hidden in the clouds. In fact, the rays are parallel, and it is only a trick of perspective that makes them appear to diverge.

● Contrasty light

Shafts of sunlight are very directional, brightly illuminating some surfaces while casting others into deep shadow. In this photograph (*above*), it is the contrast between lit and unlit surfaces that gives the image an extra dimension and additional punch.

Night photography

To take photographs at night you will often use shutter speeds
longer than are safe for hand-holding – so you will need a tripod or some
form of camera support. Night shots taken in city centres, where there are lots
of lights, or close-ups of well-lit buildings, monuments and so on, may produce
normal exposure settings but, unless you are using film designed for
these non-photographic light sources, you should expect colour casts (*see Glossary*).

● Early dusk

When the sun is just beginning to
set, there is often sufficient light for
a normal, hand-held exposure. In
this shot (*right*), shadows have
started to obscure much of the
detail, but the car's headlights and
the colour still prominent in the
sky help to enliven results.

● Late dusk

Shots taken when the sun is just
below the horizon often work best
when you include artificial lighting,
as in this photograph (*below*). This
scene is bright and colourful and
full of atmosphere, but colours are
not accurate.

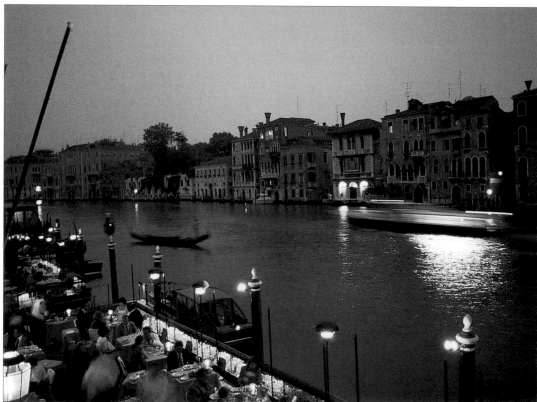

106

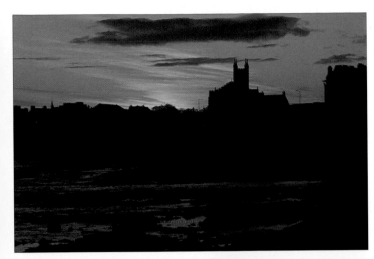

● Silhouette

When there is still some light in the sky you will find that the difference in exposure between the sky and land makes it impossible to retain detail in both. You can use this to advantage, however. In this image (*left*) the land has been thrown into heavy shadow (apart from one area of foreground reflection), by taking a light reading from the sky area alone. The dusk-streaked sky is rich with well-saturated colour, while prominent features in the landscape beneath have become dramatic silhouettes.

● Adding light

If you have a convenient light source, such as flash, then you can take pictures at night with small, local detail, normally exposed. Bear in mind that parts of the subject lit by flash will appear natural in coloration, while those subject colours lit by other forms of artificial light will look distorted. Most built-in flash units are ideally suited to this technique.

107

Flash

Due to the great lighting difference between the figure (*above*) and the background, which was out of range of the flashgun, the woman seems to be part of some dream-like image. Because her face was more reflective than her clothing, her head seems to be strangely disembodied.

Car headlights

For an unusual lighting effect at night, you could use a non-photographic light source, such as a car's headlights, to light your subject (*left*). The beam produced from this source does not give even illumination, so position your subject to take best advantage of the different lighting intensities.

● Overhead lights

The exposure for this shot (*right*) was manually timed over 15 seconds, with the camera mounted on a tripod. Some cameras can be set for exposures of this length or even longer. If not, you will have to use a camera model with a 'B setting'. The B stands for 'bulb' and means that the shutter will remain open as long as the release is kept pressed.
Headlights and tail lights of moving cars have elongated into white and red streaks, while the stationary illuminations overhead, and those elsewhere in the scene, have recorded clearly.

● Fireworks

There is no way of knowing precisely when or where fireworks will explode (*left*). The best way to photograph them is to support the camera on a tripod, with the shutter set to B, and the lens aimed at the likeliest part of the sky. Leave the shutter open until you have recorded two or three bursts. As long as the camera is perfectly still throughout, there is no upper limit for the length of exposure, but the longer the exposure the lighter the sky becomes, and this weakens the effect.

Useful tips

• The B, or bulb, setting on a camera refers to the air bulb that was used in the early days of photography to trip a camera's shutter. It is still best to use these, or their mechanical and electronic equivalents, to avoid jarring the camera during a long, manually timed exposure.

• Very intense points of light may flare into the camera lens during long exposures.

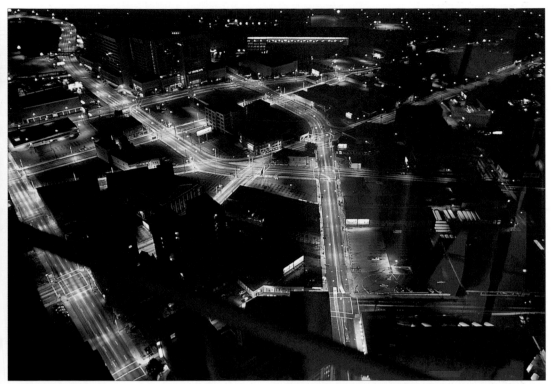

● Overhead view

The varied types of colour distortions, or casts, you can expect when using non-photographic lights for illumination can be clearly seen in this overhead view of a city centre late at night (*above*). The most noticeable colour here is the yellow outlining the roads, which could be caused by some types of neon or sodium vapour lights. The green is likely to be neon while the warmer colours are tungsten.

● Illuminated signs

If you find a well-lit sign such as this (*below*) you may need a shutter speed of only about ½ to 1 second, well within the range offered on many cameras. You will still need some form of camera support, however, to prevent camera shake. If your camera has a self-timer, use it instead of pressing the shutter normally. In this way, any vibrations will have died down before the shutter fires.

Making the best of bad weather

There is no rule that says the sun must be shining before it's worth taking a photograph. Bad weather, which often means poor light as well, can add drama and give impact to what would be an unremarkable scene in better conditions. Look out for the moment when the weather suddenly changes – the intense light from a steely blue sky just before a storm breaks, for example, can make a spectacular picture, but the light may hold for only a few minutes.

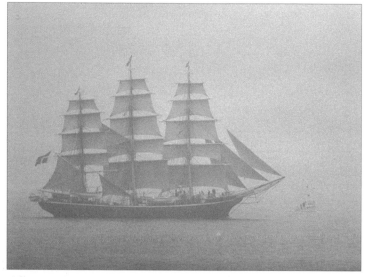

● Ghostly outline

Mist and fog mask such things as colour, texture and tone. Here, however (*left*), the bad weather draws evocative attention to the many angles and surfaces making up the ghostly outline of a full-rigged sailing boat.

● Cloudscape

Storm-laden cloud formations, stark white clouds against a brilliant blue sky, or cloud banks lit from beneath by the evening sun (*below*), may all warrant being the main subject of a photograph. The sky exposure is so bright that often any land visible in the picture becomes a silhouette.

110

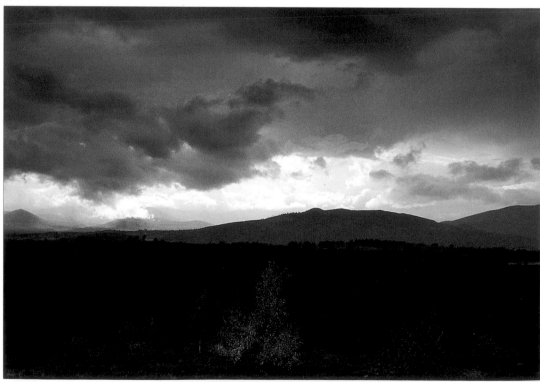

Useful tips

• In low light levels use a higher ISO setting (or a fast film) to help avoid camera shake. Alternatively use a camera support, or lean against a wall, to prevent blurred pictures.

• Always dry the camera instantly if it gets wet.

● **Approaching storm**

When the sky is heavy and light levels are plunging (*right*), colours can become very intense. As the storm nears, the scene seems to shrink in on itself – an effect heightened here by using a zoom lens set to telephoto.

● **After the storm**

The light after a storm has passed and the leaden clouds have begun to break up, can be magical (*below*). The air, now washed clean by the rain, produces a radiant, warm glow.

Snow scenes

A covering of snow, even over a familiar landscape, can produce a magical transformation. The scene is at once simplified – landmarks disappear and colours become largely monochromatic, while other features may take on added prominence. Light readings may be a problem, however, since the meter may misinterpret the light reflected back from the snow and slightly underexpose. Use exposure overrides if available or increase exposure manually if possible.

● A splash of colour

Without the brilliant splash of red in this photograph (*left*), this snow-filled front garden could almost have been shot in black and white. In order to achieve the correct exposure, a close-up light reading was taken from the little girl's face, and this was locked into the camera before the shot was recomposed and taken. This AEL (or automatic exposure lock) feature is found on many modern compact cameras as well as SLRs, and it is invaluable in situations such as this.

● Fringes of frost

If you are up early in the morning after a frosty night you may find fringes of frost still outlining the shapes of leaves, such as on this ivy vine (*below*). The sun was so weak that it could not penetrate far into the tangle of foliage, and the dark interior gives the picture a feeling of depth and mystery.

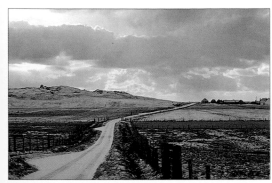

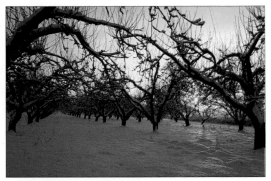

● Sky exposure

If a general snow scene is to be successful you may have to wait for a break in the clouds to admit a little sunlight into the picture, to provide an area of brightness (*above*) and dispel the impression of gloom that sometimes exists. Fortunately, the sunlight here was not strong enough to distort the light reading and exposure overall is correct.

● Added prominence

Familiar features of the landscape can take on added prominence after a fall of snow. These ranks of skeletal fruit trees (*above*), for example, appear starkly defined against the blanket of white beneath their reaching branches. The only warmth in the picture comes from the faint glow of an orange sun hovering just above the horizon.

113

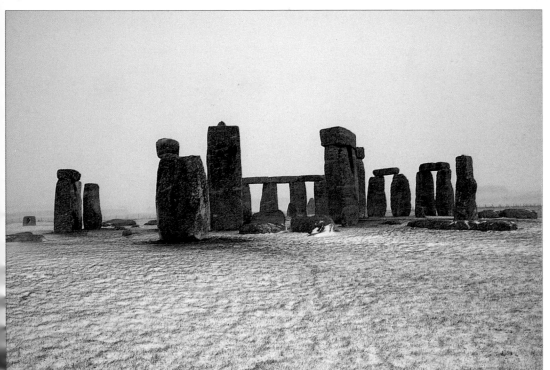

● Stonehenge

These ancient standing stones (*above*) are to be found on Salisbury Plain in Wiltshire, England, and their construction is thought to date back some 4,000 years. Seen like this, with a dusting of snow rippling the plain and a featureless grey sky hanging above, the scene takes on a mysterious timeless quality. The uniformity in colour of ground and sky is relieved only by the darker forms of the stones themselves, which appear almost as a silhouette projected against the background.

Useful tips

• In extremely cold weather, camera batteries work less efficiently and may need renewing more frequently.

• A low morning or afternoon sun helps to bring out the texture of settled snow.

• Switch to manual white balance on a digital camera to help warm up a too cold-looking scene.

Choosing a theme

Finding the inspiration for a set of photographs can be far easier if first you decide on a theme. If you don't have much leisure time, then concentrate on some aspect of your normal routine – perhaps pictures of colleagues at work or commuters coping with the daily frustrations of buses and trains. Inspiration may also come from a hobby or while on vacation. The theme here is obviously horses, and all could be photographed during ordinary family vacations.

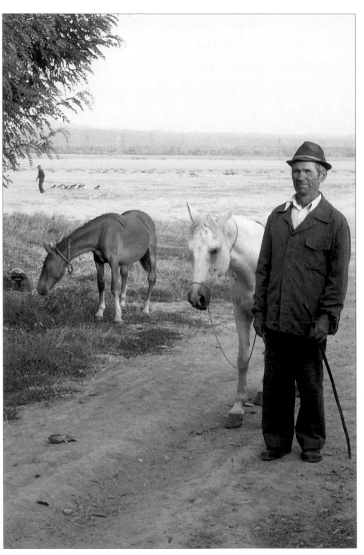

<div style="background:gray">

Useful tips

• For safety's sake, don't use flash when taking pictures of horses. The sudden burst of light could panic them.

</div>

● **After work**

In late afternoon, these horses (*above*) were being brought in from the fields in the Romanian countryside. You could just quickly snap a picture like this, but often it is better to stop and ask permission – using sign language if necessary, or just a smile.

● **At play**

By striking up a relationship with the man seen in the previous photograph, it was possible to find out where the local horses were taken to bathe, and so obtain a wonderfully evocative picture (*right*).

CHOOSING A THEME

● Riding school

With a theme firmly in mind you can seek out locations, such as this riding school (*below*), near your home or when on holiday.

● Tricky exposure

Use the exposure lock if available to fix a light reading taken from the horse, or the shadows may result in overexposure (*right*).

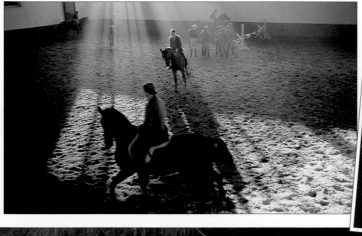

Still Lifes

When shooting still-life pictures, keep checking your arrangement through the camera's viewfinder, and don't press the shutter until the objects are positioned just the way you want them. This will be far easier if you keep the camera in exactly the same position, and at the same height, on a solid support such as a table or mounted on a tripod. Often, window light is all the illumination you need, but a simple flashgun will give you extra flexibility.

116

● Beauty and utility

Proving the worth of valuable antiques, such as these three jugs (*above*), if they are broken or stolen, will be much easier if you have a clear photographic record of them.

Useful tips

• If using a camera with built-in flash, try covering the flash head with various layers of tissue paper. This will give a softer, more diffuse type of illumination with just enough light to give detail in the shadow areas.

• If the area around your still life is cluttered and distracting, try using a sheet of background paper to simplify the surroundings. This material is available from many camera shops and comes in various colours and textures.

117

● Mixed materials

This arrangement (*above*) is a fascinating mixture of materials and textures – a feast for the eye as well as the palate.

● Reflector

The mirror in this picture (*left*) reflects light back on to the subject. Be careful not to include your own reflection in the shot.

● Kitchen clutter

With a little careful selection and tinkering, even a collection of everyday kitchen objects can be transformed into a fun subject for a still-life photograph (*right*).

Food as a still life

The popularity of food as a photographic subject is evident in the huge number of food still-life photographs to be found in magazines and recipe books. The colours, shapes and textures of both the prepared foods and their ingredients can be beautiful in their own right. Added to this, you have all the accessories – such as china dishes and plates, wooden bowls and pepper grinders, the steely gleam of cutlery and cookware – to utilize in your images as well.

● Simple arrangement
Food pictures don't have to be elaborate to be effective. This simple arrangement of fish surrounded by prawns (*right*) has been shot from overhead against a plain background so that nothing distracts from the food itself or the pierced, basketweave china plate on which it rests.

● Food shops
Food in speciality shops is laid out to be appealing. Keep alert for shots such as this shop window (*below*), and take advantage of someone else's hard work.

118

● Shadowless lighting

To record the varied colours and textures in this type of shot (*left*), you need a soft, shadowless light. If the light is coming from one direction, place white cardboard (out of view) opposite the light to reflect illumination back into dark areas of the scene.

Useful tips

• Use a textured background for most food photography.

• If shooting through a shop window, pick an angle that does not include your own reflection in the glass, or use a polarizer (*see p. 143*).

● Found still life

These potatoes (*right*) had been dug only a few hours before and been brought inside to be cleaned of soil before being laid down properly for storage. Soft window light from an overcast sky outside has produced a very harmonious found still life of earthy browns and oranges.

119

● Bright reminder

A lot of care goes into the presentation of a cocktail, making it a good subject for the camera (*above*). It might also bring back happy memories of a holiday or night out. A wide aperture was used here to ensure a restricted depth of field (*see p. 138*).

Architecture

People often take photographs of buildings when they are on vacation or on their travels. Often, too, it is the style of buildings and the colours used to decorate them that signal most strongly and immediately that you are 'somewhere else'. Specialized equipment is needed only occasionally for good pictures, but you will usually be dependent on natural daylight and may have to return to some places at another time of day when the sun is in a better position.

● Formal composition

A bold, broad sweep of water, encompassing the entire width of the foreground (*right*), grabs the attention of the viewer and draws the eye firmly towards the magnificent building in this example of linear perspective (*see pp. 38-9*). Manicured lawns and woods either side of the building act as frames to define and enclose the structure, and the clouds above, which are also reflected in the waters beneath, are almost an unnecessary embellishment to this wonderfully formal composition.

● Gain the high ground

If your subject is a rambling old manor house such as this (*below*), you will need to find a high vantage point in order to show all of the building at once. An added advantage of such a camera position is that it also shows the setting to good effect, and the bare winter branches here act as a type of vignette, producing a surprisingly intimate image, as well as increasing the sense of depth and distance.

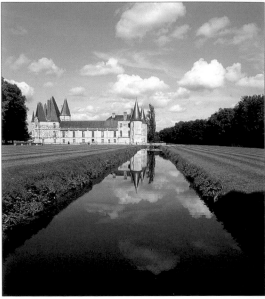

● Bare essentials

The rigid symmetry of this painted wooden building (*above*) has been echoed in its framing in the photograph – solidly dead centre. Even the line represented by the foreground hedge is perfectly straight, creating a fitting frame for the structure. Reducing composition to the bare essentials can impart real impact.

● Critical light

The lighting for this shot was absolutely critical (*above right*). The white-painted buildings sit perfectly against a deep blue tropical sky, but it is the heavy foreground shade that provides that all-important contrast in tones and gives the picture extra strength by forming a solid foundation. The wide-angle lens setting used here makes the palm tree look a little precarious, but it is ideally placed to balance the tall bell tower on the right.

● Abstract treatment

Photographs of buildings don't need to be literal affairs – you can be as imaginative in this subject area as you can in any other. Modern buildings (*right*) lend themselves to this type of abstract treatment , and showing the setting may only be a distraction.

Cityscapes

Many cityscapes are disappointing because they have no readily discernible centre of interest. If you use a wide-angle lens setting, everything tends to look small and insignificant in the frame; with a telephoto lens setting you need to be very selective. Rather than trying to cram too much in, use as your main subject some feature that is easily recognized as belonging to that city, or select small details to evoke something of the atmosphere of the location.

● Visual icons

The Statue of Liberty (*below*) immediately identifies this cityscape as being of New York.

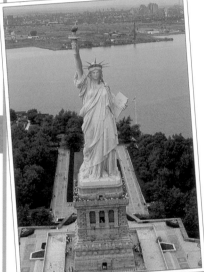

• A New York taxi (*below*) establishes the location even before you see the other clues. The foreground has been filled, and subject details extend right to the background.

• Tower Bridge (*above*) is enough to identify London as the subject here. Night pictures can be very atmospheric, and the slight mist adds to this.

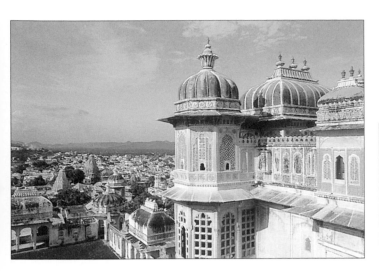

● Gaining height

Find a high vantage point for a bird's eye view (*left*). A greater feeling of space and distance is apparent if there is a strong foreground, such as a building.

Useful tips

• Include reflections to show more of the city in one shot

• For distant, general views, early mornings are usually best before the air becomes too filled with exhaust fumes.

● Details

If you take the time to look you will find a wealth of fascinating architectural details in nearly all city locations. Keep a careful watch for shop windows crammed with local and imported produce (*right*), traditional tiled facades (*below*) and painted signs advertising the goods or services within (*below right*). Such topics could become the theme for a series of related pictures.

123

Mirrors and windows

Devices such as mirrors and windows can be used to give some of your photographs more interest, turning them into compelling pictures that are also fun to take. Mirrors can introduce a mysterious element, allowing glimpses of what is usually hidden and stimulating the imagination. They also reflect available light, which can help in dimly lit interiors. Windows can be used as frames within frames (*see p. 50*) and also as surfaces to catch reflections (*see pp. 126-7*).

● Two in one

In these two photographs, mirrors have been used to show the viewer different aspects of the subjects, as well as revealing far more of the setting than could be achieved from any single camera position. In the candid profile shot of a little girl pulling faces in the bedroom mirror (*right*), we can see more of her comical expression in the smaller side mirror; while in the other (*below*), the mirror allows us to glimpse the attractive stairway behind the figure and also introduces a sunny highlight that brightens the whole composition.

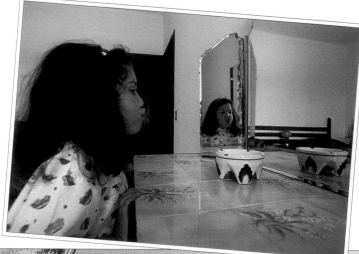

124

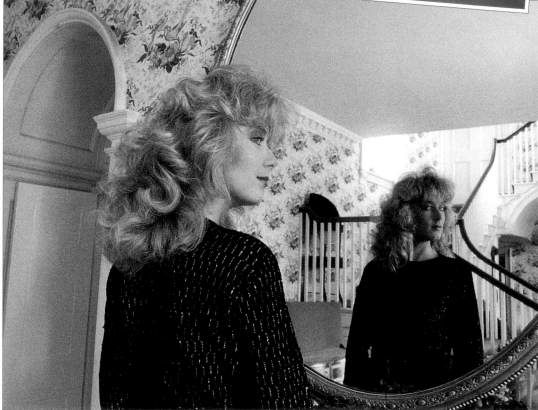

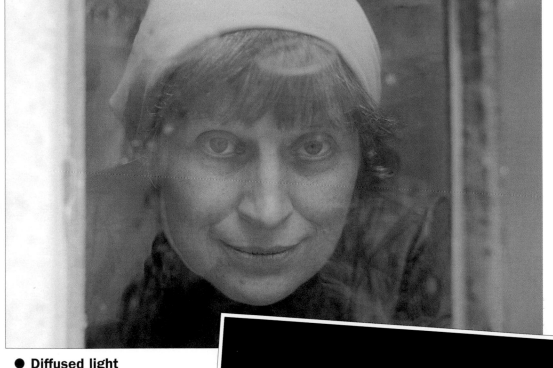

● Diffused light

By positioning the woman directly behind the window pane (*above*), her face has been overlaid with faint reflected detail from the scene outside. This has softened and diffused her appearance as well as giving her a dreamy, far-away look.

● Contrasty light

Shooting from inside a dark room at a figure outside (*right*) has created a scene of deep shadows and bright highlights. The Gothic window not only acts as a frame, it also gives a feeling of depth by introducing an immediate foreground element.

Useful tips

• A problem when photographing a reflection is not to include your own image in the picture. Shoot from well to one side of the subject or from a camera position below the reflective surface. Making the subject large in the frame also helps to exclude extraneous reflections.

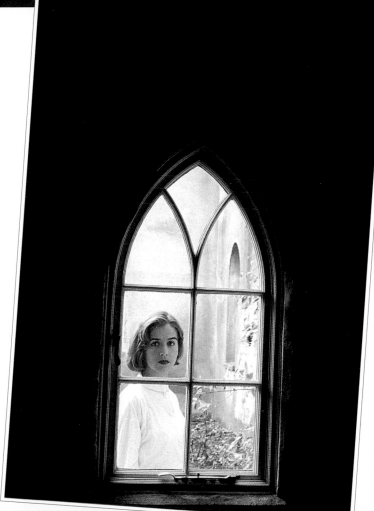

Reflections

You can use reflections – from water, metal, glass, or any shiny surface – as part of a general scene or as the main subject of a photograph. Used just as one element, they can give pictures extra colour and sparkle, as well as adding visual information in what might otherwise be lifeless areas of the frame. When used as the main subject, strange and exciting abstract patterns may emerge.

● Water

Without the eddies of blue and yellow reflected in the water of this shot (*right*), most of the picture area would comprise a murky grey colour. Note, where the water is calm, the perfect repeated image of the duck's head and gracefully curved neck.

● Foreground interest

At dusk you find there is often still enough light for a good picture and you can, as here (*below*), use a reflection to add extra detail and interest to what might have been blank areas of a shot.

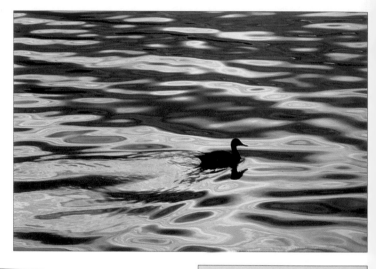

126

Autofocus

• Some autofocus compact cameras measure the distance to the subject by transmitting a beam of infrared light. This is known as an active autofocus system (a different system is used on digital cameras and SLRs). However, it may cause problems if, as in the picture on the opposite page of a glass building, you want to focus on the reflection itself and not just on the reflective surface. This is because the reflection of an object is effectively farther away than the surface in which it is seen.

• Even with digital cameras and SLRs it may be safer to, switch to manual and focus visually on the reflection.

• If you can change apertures, select a small one to increase overall sharpness (*see pp. 138-9*).

Useful tips

• For reflections in water at night, choose a camera position where the reflections help to fill areas of deep, featureless shadow.

• With a manual camera, focus on the reflection and not on the reflective surface.

• Small changes in camera position can make large differences to the appearance of reflections, so always check using the camera's viewfinder.

● Glass

Modern, glass-fronted buildings make ideal reflective surfaces. You might, as in this example (*right*), want to show a more traditional building reflected in the glass of the new to provide a stark contrast in styles.

● Metal

Reflections in a polished metal plate (*below*) give intriguing glimpses into a distorted copy of the real world.

127

Sports and action

If you are interested in shooting sports photographs, then the closer you can get to the action the better. In this respect, you will probably have more luck at amateur events than professional ones. Anticipation is vitally important to successful results, too. Often, though, it is the action-stopping power of your camera that makes all the difference. A long telephoto lens setting coupled with a fast shutter speed are the two ingredients needed for a conventional sports picture.

● Sideline action

For a different type of sports picture, concentrate on the sideline action, as here (*right*), and use the competitor as the secondary element of the composition.

● The main event

In contrast to the image above, this is a more traditional approach (*below*). A telephoto lens setting has brought the figure up large, and the autoexposure has handled the situation well.

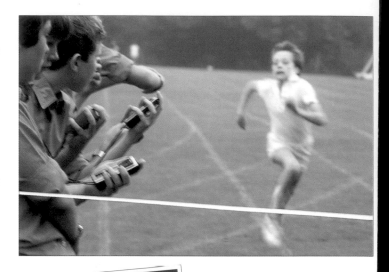

128

● Overhead shot

Rowers (*below*) tend to practise on rivers where the public have ready access. The best way to capture the action here is to position yourself on a bridge over the course and wait for the boat to come to you. These boats are so long that a moderate wide-angle lens setting is sufficient.

• Always look for unusual angles and views to give a different slant to your pictures.

• Panning, moving the camera in line with the subject as you expose the picture (*see p. 62*), can be very effective.

● Peak of action

If you can't alter shutter speeds, then wait for the peak of action, when the athlete is momentarily still (*above*), before pressing the shutter release.

● Using flash

In this picture of a competitor performing her beam exercises (*left*), the flash has frozen her display at what seems like an impossibly contorted moment.

● Anticipation

Anticipating where the action will occur, and having quick reflexes, are two of the keys to successful sports and action photography. You can see in the picture of the water-skier (*below*), the impact images have when composition, camera position and timing all come together simply because you have anticipated and planned the shot ahead of the action. This is one of the most telling aspects of this type of photography.

129

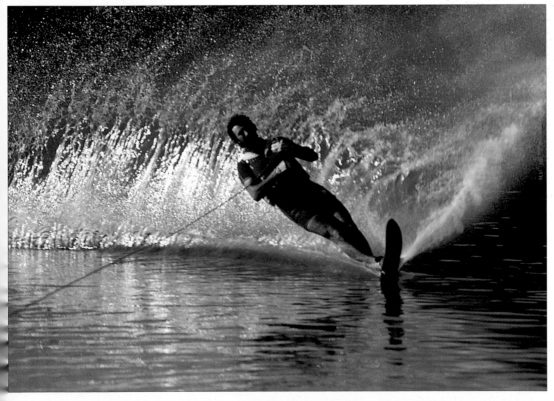

BEYOND THE BASICS

If you have a sophisticated compact camera offering a choice of exposure modes and manual overrides, or if you use a single lens reflex camera, then there are other techniques you can employ for more advanced results.

Interchangeable lenses

The ability to change lenses – from a wide-angle, say, to a telephoto – is one of the great advantages of using an SLR. Wide-angle focal lengths (anything shorter than about 35mm) are very useful for broad panoramic scenes or when space is tight and you can't move far back from the subject. Telephotos (longer than about 85mm) are excellent for subjects such as portraiture, sports and action, nature and candids, where you need a big image of a distant or small-sized subject.

● Telephoto shot

The three shots on this page of the same subject illustrate the effects possible with different lenses. The first (*right*) was taken with a 250mm lens setting, and its very restricted angle of view gives a detailed close-up of the crest of arms and emblem beneath.

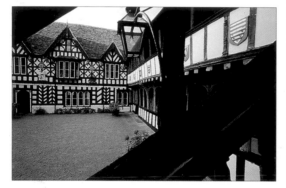

132

● Wide-angle shot

Taken at about the same distance from the building as the version on the right, this wide-angle shot (*above*) gives an entirely new perspective on the scene. The courtyard is now visible and seems very deep indeed, an effect created largely by the tendency of wide-angles to exaggerate the distance between near and far objects in the same scene. The lens used here was a 28mm.

● Standard lens shot

This lens gets its name because its angle of view is about the same as standard vision – with a zoom setting of around 50mm (*left*) you can see the building and courtyard in their correct relationship. Non-zoom 50mm standard lenses are a useful for digital SLR users because they are relatively inexpensive, but typically have a much wider maximum aperture than any zoom. This makes them invaluable for lowlight situations.

INTERCHANGEABLE LENSES

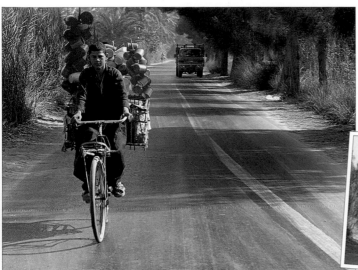

● How much to include?

No one lens is necessarily better than any other. The wide-angle shot (*left*) is successful because it shows us the whole figure, his strange cargo and setting. The telephoto version (*below*) is more of a facial study, and with the bicycle gone, so is all the humour.

● Zoom lenses

Zooms can be bought with a wide range of focal lengths, offering an all-in-one solution for most photographic subjects. They are big, but offer the versatility of being able to take distant views (*left*) as well as detailed close-ups (*above*) without changing lenses. Note that the effective focal length of a lens on a digital SLR may be different to that marked on it – as the angle of view will depend on the size of the sensor.

Try for yourself

• Find a scene with a detailed and reasonably distant central feature, one that also has features of interest at the sides of the frame.

• From the same camera position, shoot one picture with each type of lens and compare the results.

Macro photography

Moving in extremely close to common, everyday objects can reveal a world of form, colour, shape and texture, you never suspected was there. 'Macro' in photographic terms is used to mean life-sized images of objects, but most us know the term from the special focus setting found on many zoom lenses and compact cameras. Using this setting puts the lens well forward of the camera body and so allows very close focusing distances – but not necessarily ones producing life-sized images.

● Composition

Even on the macro level, you need to pay attention to composition. In this shot (*right*), the horizontal framing includes too much background compared with the size of the dandelion. Closer cropping would improve results.

● Reorientation

By coming in low to look up at the subject (*below*) and shooting against the light, not only is the cluttered background of the first shot removed, the seed head has also been transformed into a textured ball of silken thread.

134

Useful tips

• For those interested in macro photography, specially designed lenses are available, as well as bellows units and rails and extension rings that sit between lens and SLR body and allow extremely close focusing.

• The viewing screen of an SLR always shows the image as seen by the lens, so no matter how close you focus you can still judge lighting, composition and so on.

● Use the light

By changing the camera position for this shot (*opposite*) the head of the dandelion is seen against the yellow disc of a setting sun. Now the seed head is illuminated largely by light filtering through the hair-like filaments, starkly revealing the seeds themselves.

Exposure

Exposure refers to the intensity of light reaching the image senor (or film). It is controlled by the lens aperture, and the length of time that light is allowed to act, or shutter speed. 'Correct' exposure, however, needs to take into account the ISO setting of the film being used – fast speed or sensitivity needs less exposure than slow. Also important is the way you want the final image to look – lighter or darker than 'normal'.

● Exposure for effect

These two photographs illustrate that caution is necessary when talking about 'normal' or 'correct' exposure. In the first (*right*) a deliberately light exposure gives a delicate, porcelain-like effect to the subject's skin. This is known as a 'high-key' image. The 'low-key' image (*below*) is deliberately darker than normal, and this type of exposure can impart a sense of mystery or intimacy.

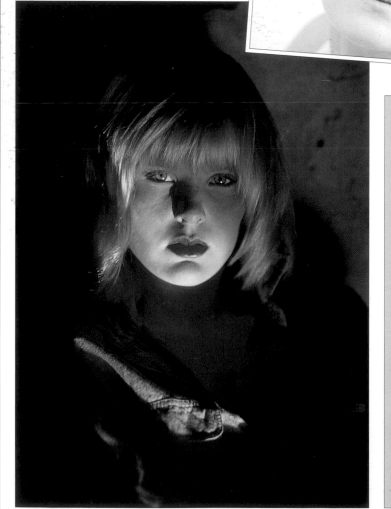

Useful tips

• Bracketing exposure (*see right*) is more useful for static scenes than action events.

• With digital cameras, the unwanted frames of the bracketed sequence can be deleted, to free up memory.

• Many cameras offer automatic bracketing modes – otherwise use the exposure compensation dial to make the different settings.

• If depth of field is important (*see pp. 138-9*), work out the aperture required and alter the shutter speed alone in order to alter the exposure. With a moving subject, the correct shutter speed might be vital. In this case, select the most appropriate shutter speed (*see pp. 140-1*) and bracket the exposure by varying the aperture alone.

● Bracketed exposure series

When you are uncertain about the correct exposure to give a subject, it is a wise precaution to take a bracketed series of photographs, as shown on this page. To do this, you need a camera that provides some way of overriding the exposure. As a starting point, use the exposure reading suggested by your camera's meter and then take one shot giving two stops extra exposure, another with one stop extra and the third at the setting suggested by the meter. Next, do the same, but underexposing by one stop and then two stops. When you see the results you will be able to judge which one produces the type of effect best suited to the subject.

137

Where to focus

No matter what distance the lens focus is set at, there is an area in front and behind that is also acceptably sharp – this is known as the depth of field. The extent of the depth of field varies depending on lens aperture (the smaller the aperture the greater the depth of field) and focal length (the longer the lens or setting, the shallower the depth of field at any given aperture).

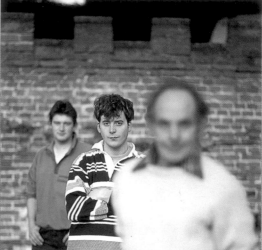

● Foreground figure

Using a lens at 85mm (*above*), and at its widest aperture (f2), focus was carefully set on the foreground figure. Depth of field is so shallow that only this first figure is in sharp focus.

● Central figure

The only difference in this picture (*above*) compared with the first is that the focus setting has been changed so that the central figure is now sharp.

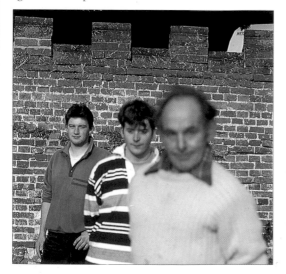

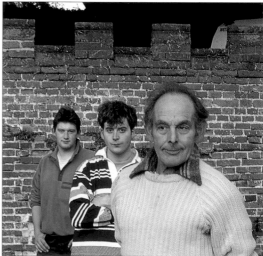

● Background figure

In this shot (*above*) you can see that now the background figure has been focused on. Note that as the focused distance increases so, too, does depth of field, even at the same aperture and focal length.

● Change of aperture

The greatly increased depth of field seen in this picture (*above*) results from using the smallest aperture available on the lens (f22). Focal length was still set to 85mm and the middle figure was focused on.

138

● Creative focusing

Once you understand how depth of field works you can start to use focusing as a creative device. If, say, you wanted to emphasize the middle ground of a photograph, you could select a focal length and aperture that rendered the rest of the scene less than sharp. On the other hand, all elements of a picture may be important, and by selecting the right focal length, aperture and focus distance you could ensure everything is clearly focused.

Shallow depth of field

If this photograph of spring-time flowers (*above*) had been taken using a small aperture, everything would look sharp and it would have been hard to see what the actual subject was intended to be. By coming in close, however, and selecting a wide aperture, you can see that it is the foreground primulas that are the important subject element. This selective rendering of image planes in or out of focus is often referred to as 'differential focus'.

Great depth of field

For this picture (*left*) it was important to see every detail. In order to achieve this, an aperture of f22 was required. Small apertures such as this require long shutter speeds to avoid underexposure, however. Some modern cameras offer exposure modes that maximize depth of field, selecting the smallest possible aperture at the expense of shutter speeds.

Try for yourself

• Find a subject such as an avenue of evenly spaced trees stretching away from your camera position. A line of posts marking the edge of a road is another possible subject.

• Take a set of test pictures as described opposite in which you change just focal distance. Then take another set in which focus remains the same but you change lens focal length.

Shutter speed

The shutter speed set on the camera manually or automatically, along with the aperture, determines how much light reaches the film, and so is a vital component of exposure (*see pp. 136-7*). But shutter speed can also be used creatively. Fast shutter speeds tend to 'freeze' moving subjects, allowing you to look at the very anatomy of movement. A slow shutter speed, however, may record moving subjects as evocative, elongated blurs and streaks.

● Slow or fast shutter?

Whether you use a slow or a fast shutter speed with a moving subject depends on the type of image you want – as you can see from the two versions of the same scene here. In the first (*right*) the movement of the water was stopped using a shutter speed of ⅟₅₀₀ second. For the second image (*below*), the shutter speed was changed to ¼ second. Even with the lens aperture closed down to its smallest setting, however, the image would have been overexposed without the use of a neutral density filter to restrict the light passing through the lens.

140

● Creative use

Once you understand how the shutter affects the image, you can start to use it as a creative part of your photography.

Dim interior

A shutter speed of ⅛ second records the atmosphere of this candle-lit interior (*right*).

Action-stopping

A shutter speed of ⅟1000 second allows you to capture all of the horse's feet off the ground at once as it gallops by (*below*).

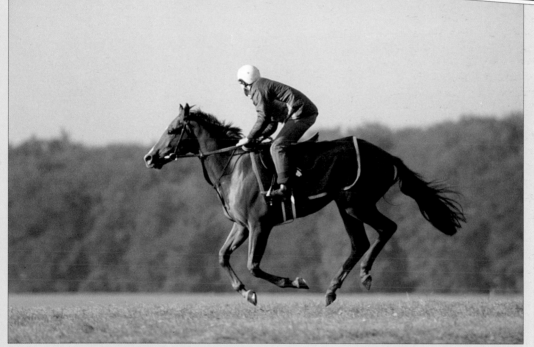

Shutter and aperture combined

The two camera controls that affect exposure are the shutter speed and aperture. The aperture controls the intensity of light reaching the film, while the shutter determines how long that intensity of light is allowed to act on it.

If you were to double the intensity of the light reaching the film by opening the aperture up by one f number (from, say, f8 to f5.6), and then you were to select a shutter speed that was twice as brief (from, say, ⅟125 to ⅟250 second), in terms of exposure the same amount of light will have reached the film

and both will be correct. From this you can see that for virtually any subject, there is a whole range of different shutter speed and aperture combinations that will result in correct exposure.

If you decide that shutter speed is the most important factor (to freeze action, for example), set that first and then determine the appropriate aperture. If, however, aperture is most important (because of depth of field, for example – *see pp. 138-9*), then set the appropriate f number and then select the corresponding shutter speed to give correct exposure.

Filters

Filters for lenses fall into two types. First are those intended to manipulate the way film reacts to subject colours, in order to correct, say, a cold-looking image (warm-up filters) or to eliminate reflections from water or glass (polarizing filters). The second are those types known as special-effects filters. These include starburst, split-colour, graduated colour, and many, many more. The more intrusive the filter on the image, the more restraint is needed in its use.

● Yellow filter

The use of a yellow filter for this picture (*below*) has turned an ordinary landscape into a nightmare setting. Used with black and white film, however, a yellow filter will strengthen tonal contrast between, say, clouds and sky.

● No filter

This landscape shot (*right*) is shown to allow you to compare directly the startling transformation an image can undergo when a solid-colour filter is used.

Using filters

• Many filters are better suited to use on film cameras than on digital cameras. Colour balance filters are unnecessary, for instance, as colour casts can be corrected for using white balance adjustments. Other filter effects, such as graduated skies, are more easily achieved using image manipulation programs.

• You can see the effects of a polarizer on an SLR viewing screen as you turn the filter. With a compact, hold the polarizer to your eye and rotate it until you see the best effect. Then transfer the filter to the lens without changing its orientation. With most autofocus cameras, a circular polarizer filter should be used.

● Polarizing filters

A polarizing filter acts like a pair of sunglasses. By removing reflections from some surfaces it can allow the lens to see past, say, a window full of reflections or the dazzling surface of a pond.

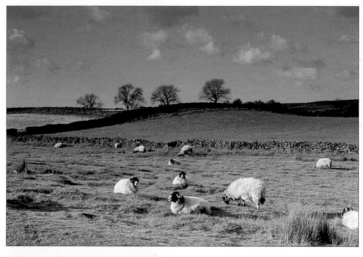

With polarizer

In this picture (*left*) a polarizer has been used to remove reflections. Note how strong surface form is.

No polarizer

Taken without a polarizer (*above*) from the same position as the first shot, the statue's form is less pronounced.

● Graduated filter

A graduated filter, as you can see in this shot (*right*), gradually strengthens in colour, starting off pale and becoming quite pronounced. Orientate the filter so that the stronger colour overlays the part of the image that will benefit most.

● Split filter

A split filter is half one colour and half another (*below*). Turning the filter reverses the colours top to bottom, turns them on their side, or runs them diagonally across the image area.

143

Useful tips

• Round screw-in filters are bought to fit a particular lens. Square filters fit into a frame, which can then be attached to a range of different lenses.

• When using a wide-angle lens or setting, make sure the rim of the filter does not intrude into the image area.

• Many filters cut the amount of light reaching the sensor or film and need a longer shutter speed or larger aperture.

Cropping the image

In an ideal world, all the elements of subject matter included in the viewfinder when you take your picture are just as you would like them to be. In reality, sometimes it is not until you see the picture blown up on your computer screen, or the finished prints, that you realize that some pictures could be improved – by cropping out a distracting element at the top or side, or perhaps by changing the shape of the picture altogether.

144

● Placing the horizon

The framing of this shot (*above*) shows the horizon and line of distant hills nearly, but not quite, cutting the frame in two. Composition could be improved either by centring the horizon or by placing it more obviously towards the top or bottom of the frame.

● Cropping for symmetry

In this version (*below*) of the first picture, a pair of scissors was used to crop the image top and bottom to bring the horizon into centre frame. The extreme horizontal shape to the image now helps to draw the eye right across the scene.

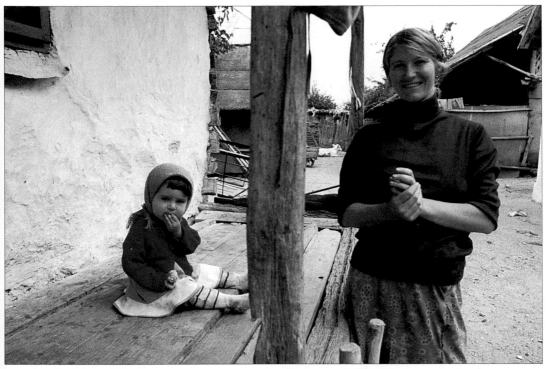

● Competing subjects

The wooden support (*above*) splits the frame un-comfortably in half, creating two distinct subjects that compete for the viewer's attention.

● Single subject

In this version (*below*), the image was cropped on screen using a basic image editing program, to create a square-shaped blow-up of the toddler.

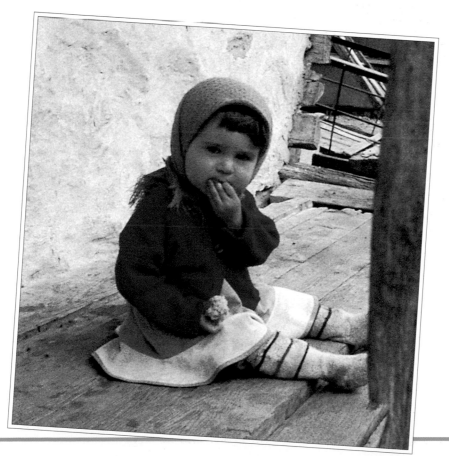

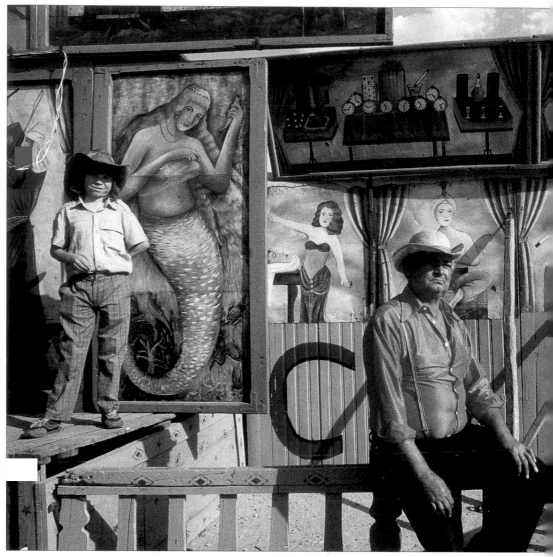

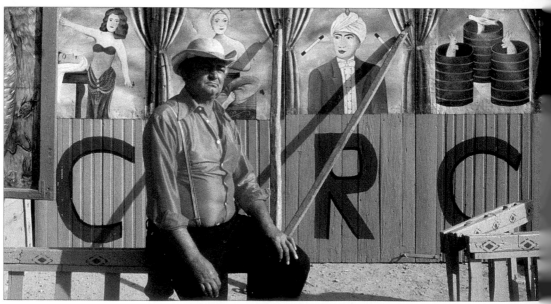

CROPPING THE IMAGE

● Full and detailed subject

This original, full-frame photograph (*left*) is full of colour, interest and fascinating subject detail. There are, however, many competing elements presented in this photograph, and it is difficult to see what precisely is intended to be the main centre of interest. The two versions below are suggestions as to how you might crop a similar type of photograph of your own.

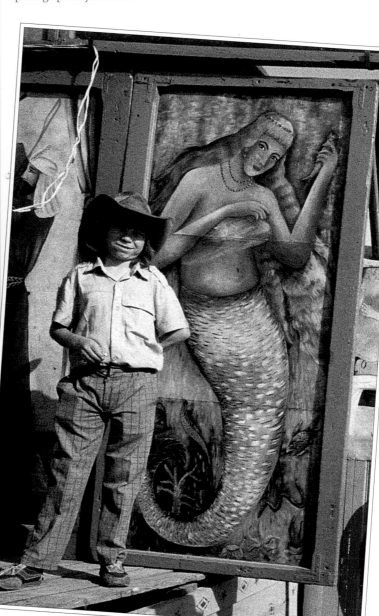

147

● On the third

This version (*left*) places the man about one-third in from the left of the frame, always a very dominant position (*see p. 52*) As a result, the viewer's eye is drawn directly to him. This is the type of thing that is best noted before the picture is taken, so that cropping takes place in the viewfinder. But there is no reason to think of the traditional shape of the photograph as being sacrosanct – if some part is not to your liking, then simply chop it off.

● Major crop

Looking at this heavily cropped version (*above*) of the picture, you can see the potential that sometimes exists for 'images within images'. What we have is still a colourful and detailed shot, but one in which there is now no doubt as to the main subject. Being able to make such major crops, and still get a decent-sized print, is one of the best arguments for always shooting digital images at the highest resolution that your camera allows.

Digital darkroom

Once you have transferred the images from your digital camera to your computer, each shot becomes a canvas that can be endlessly manipulated and enhanced. All recent PCs are up to the challenge (although some will execute the transformations faster), and often basic editing software is provided with the camera. However, for the best range of tools and adjustments choose a package like Adobe's Photoshop Elements – the low-cost brother to the full Photoshop programme, used by most professionals. Images that were shot on film can also be manipulated, once they have been digitized using a desktop scanner (usually best suited to prints) or film scanner (which is designed specifically for negatives and slides).

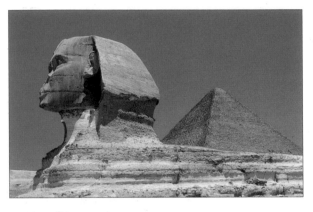

1 The sky in this shot (*left*) was selected using the Magic Wand tool (*above*), which lets you pick an area defined by its brightness.

148

● Making the selection

Many of the adjustments and effects can be applied automatically to the whole image area. However, for best results it is preferable to make corrections manually, and only apply them to the areas that really need the adjustment. Selections can be made using a variety of paintbox-like tools – either directly picking the pixels to be worked on, or drawing a mask that identifies the areas that are to be left untouched. You can select the area that you want to work on in a variety of ways – based on its colour, its outline, brightness and so on.

2 The saturation of this selected area of sky was then enhanced using the Hue/Saturation control (*above*). By tweaking the sliders, the sky can be made to be the same rich colour seen in all the postcards and holiday brochures (*left*). If you don't like the effect, you can undo the change.

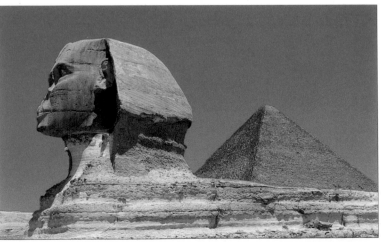

● Using elements from other photos

An advantage of a good image manipulation programme is the ease with which it allows you to undo changes that you have made, without having to start again. The layers facility, for example, allows you to make adjustments to copies of the image, without changing the original 'background' image. This facility can also be used to successfully combine two or more different images into a single finished composite. It allows you to replace a dull sky, for example, or to combine two or more imperfect shots of a particular scene in order to make one perfect one.

Edit in Standard mode

Edit in Quick Mask mode

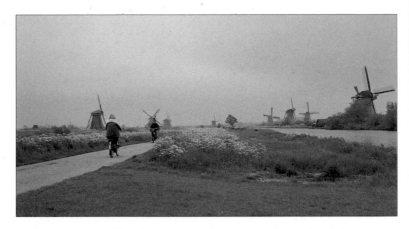

1 The composition of this shot is nice, but the featureless sky is rather drab. However we can replace this with a sky from a different photo. First the magic wand is used to highlight the sky (*see opposite*). If the edges don't exactly match the horizon of the picture, change to Quick Mask mode, which will give you a red mask that you can add to or erase from using the brushes or eraser tool. Once the mask fits perfectly, change back to standard edit mode (indicating the selection with 'marching ants').

2 Open the image you wish to take your new sky from, in a new window. Select the sky area, (you can simply use the Rectangular Marquee tool to drag across this area as you don't have to be too precise) and copy it.

149

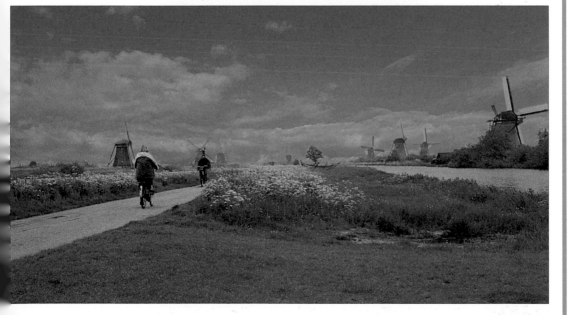

3 Go back to your original image and from within the Edit menu, choose 'Paste Into'. You will now see your new sky positioned where the old one was. If the new sky is too small or in the wrong position you can drag it around, or scale it using the Transform tools. In the Layers window your sky has automatically been put onto a new layer with a mask. If you save the image with the layers, you will be able to adjust the mask (or reinstate the original sky) any time in the future.

Digital image correction

Although the psychedelic effects and the carefully crafted composites often get all the limelight, it is the simple, barely noticeable corrections that editing software allows, that are usually the most useful. In digital photography you really can turn a poor picture into a great one. Distracting elements in the composition – such as road signs and litter – can be painted away, simply by 'cloning' a suitable area from the image onto the offending object. You can also make significant improvements to colour balance and exposure.

● Removing blemishes

The Rubber Stamp tool allows you to paint over one section of an image using another as a source. This is the simplest way in which to remove dust marks and scratches from a digitized picture – or to remove unwanted elements from the composition. Healing Brush tools perform a similar function, but try harder to merge the new material into its surroundings – making the task of choosing a suitable source area less critical.

150

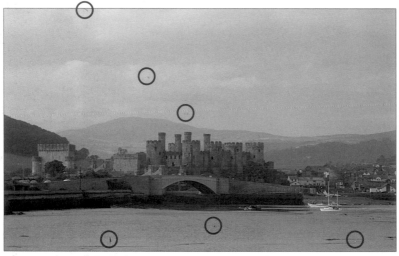

Dust is a common problem with scanned images of prints, negatives and slides (indicated with circles on the example, *left*). These can be removed by painting over using cloned pixels from nearby areas.

Rubber stamp

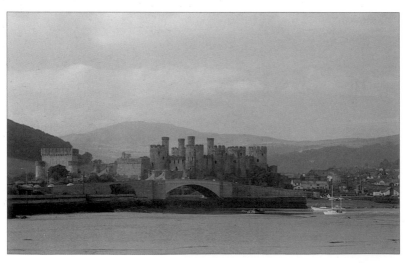

The retouched version

● Changing colour and exposure

Exposure and contrast can largely be corrected by using 'curves' and 'levels' adjustments to alter the tonal range of the image. Colours can be manipulated evenly across the picture to remove an overall colour cast or to correct the white balance – or hue,

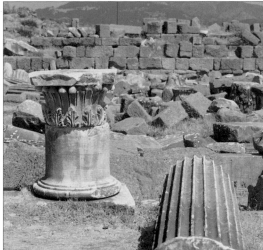

saturation and lightness of individual colours can be selectively altered for artistic effect. In the scan of the old slide (*above right*) there is a noticeable purple colour cast. This can be corrected using the Color Balance control, using the sliders in combination until a more neutral result is obtained (*right*).

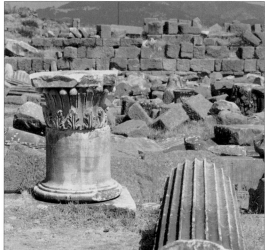

151

● Toned monochrome

In the digital era, any colour picture can easily be converted into black and white. It is also possible to tone monochrome images without the need for foul-smelling chemicals or a darkroom. Using the Hue/Saturation command, it is easy to create a sepia-toned effect – to give an old-fashioned look to a photograph (*right*).

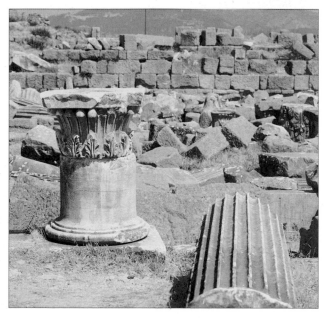

Simple digital effects

In addition to the basic image adjustments, programs such as Photoshop Elements provide a wide range of special effects or filters that can be applied to the image. Even more can be added with the use of 'plug-ins' – supplementary pieces of software that work from within Photoshop and other compatible programme. These plug-ins and filters can create digital versions of old darkroom techniques: they can be used to correct the distortions that are inevitable when using certain lenses or cameras; and they can adjust the image to look as if it was created in another medium (such as watercolours or stained glass). Third-party plug-ins, which are typically downloaded from the internet and trialled before purchase, often provide a simplified way of making a particular adjustment. One of the most useful filters is the Unsharp Mask (or USM). This is a sophisticated way of sharpening the edges and contours of an image. It needs to be used on most camera images and scans, as digital images are inherently soft. The amount of sharpening will depend largely on how the picture is to be used.

● Correcting perspective

If you tilt a camera to fit in the top of a building, the parallel lines of the structure will appear to converge. This side-effect of wide-angle lenses can be corrected on the computer – the software simply stretches the top of the image and squeezes its base. Images can also be distorted in unrealistic ways for artistic effect.

1 As the wide-angle lens needed to be tilted in order to get the whole of the French shop front in the frame, without too much pavement, the sides of the upstairs windows have become tilted.

2 By distorting the image, the vertical lines of the building can be be made to run parallel again. A drawback is that the shot needs to be cropped so as to keep the overall rectangular shape of the picture.

SIMPLE DIGITAL EFFECTS

● Using blur selectively

One of the more useful filter effects allows you to blur distracting backgrounds, recreating a shallow depth of field effect (*see p. 139*). The trick concentrates attention on the main subject – and can be useful in situations where it was not possible to use a wide enough aperture or long enough lens to restrict depth of field using usual techniques. The Gaussian Blur filter is used for this – and is applied selectively to parts of the picture. As the amount of blur is variable, it is possible to make the background as out of focus as you want to, and to make some parts of the image even less sharp than others.

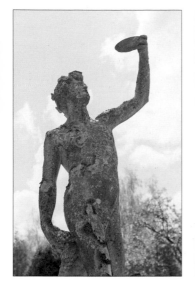
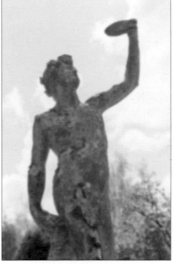

Although the background in this shot of a statue (*above left*) is not sharp, it is still identifiable and slightly distracting. By selecting this area, it can be blurred using the Gaussian Blur tool. A setting of 8 pixels gives a realistic looking result (*above centre*). A more extreme setting of 30 pixels gives a more stylized result (*far right*).

153

● Artistic filter

Filters often provide simple ways of transforming images in an artistic way. They usually work better on simple, graphic compositions, rather than on more complex scenes. In the examples here the shot of the old truck (*left*), is given the look of a scene viewed through textured glass (*far left*). As with all special effects, these artistic filters should be used with restraint; viewers will soon get bored with them if you use them too often.

Common faults

No matter how good automatic camera systems become, there will always be the possibility of error. Sometimes, faults can be put down to careless handling. With digital cameras, for instance, you can accidentally delete the wrong frame – or a whole sequence that you wanted do keep. For this reason, it may be better to edit down your images once they have been transferred to a computer. With compact cameras, the most common error of this type is allowing a finger, camera strap or part of the case to obscure the lens as the picture is taken. In a compact, the scene is viewed through a direct viewfinder window (*see pp. 10-11*), so an obstruction won't necessarily be obvious. Apart from autofocus problems, which are not uncommon, the most usual complaints about modern cameras involve over- or underexposure. Sophisticated models, which may feature two or three different exposure metering systems, can cope with most situations if the user understands the implications of each mode and recognizes the types of lighting situation best suited to each. But even basic models may offer a backlight-compensation control to prevent the main subject underexposing if it is shot against the light.

● Obstruction

Problem Part of the camera strap or a finger strayed in front of the lens (*right*).
Solution With a compact camera keep your fingers well away from the lens and check for obstructions before taking each shot.

● Film end

Problem Trying to squeeze an extra frame from the film (*below*).
Solution No harm in trying but cover yourself by taking another shot on a new roll if the picture is particularly important.

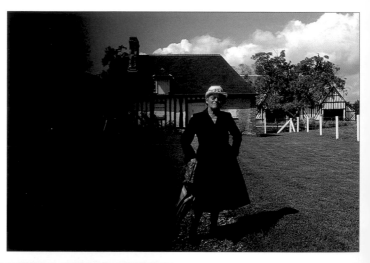

Useful tips
• In order to minimize the likelihood of errors occurring, follow this basic checklist:
1 Check batteries are working.
2 Check that the memory card or film is loaded in the camera.
3 Check that all exposure-compensation controls, white balance overrides and other modes are properly set.
4 Ensure a suitable ISO setting is being used for the lighting conditions and subject, or for the film being used.

154

● Overexposure

Problem A lens aperture too wide or a shutter speed too slow, or both, has been selected (*right*).

Solution Metering systems do not get it right every time. Check results for each shot on the LCD screen, if shooting digitally, so you can see when you need to reshoot (set exposure compensation to a negative amount to avoid over-exposure). With known difficult subjects, bracket to get a range of shots with differing exposures. Faults can partially be corrected for using manipulation software.

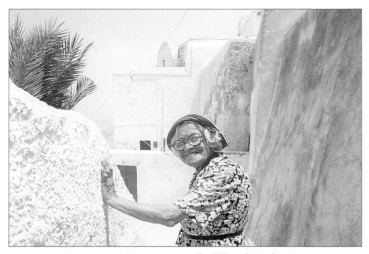

● Underexposure

Problem A lens aperture too small, or a shutter speed too brief, has been used (*right*).

Solution Built-in metering systems do not get it right every time. Check results for each shot on the LCD screen, if shooting digitally, so you can see when you need to reshoot (set exposure compensation to a positive value to avoid underexposure). With known difficult subjects, bracket to get a range of shots with differing exposures. A certain amount of underexposure can be corrected for using digital manipulation software.

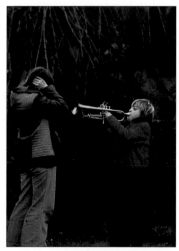

● Film fogging

Problem Light reaching the film through an ill-fitting camera back, or opening the back when there is film inside, will give results that look like this (*below*).

Solution With cameras that don't automatically rewind after the last frame of film is taken, make it a rule always to check that the film has been rewound into its cassette before opening the camera. A narrow band of fogging present on all films may indicate that the camera is not completely light-tight, and this fault will need the attention of a professional camera repairer.

155

Glossary

A B

Aerial perspective An effect, most usually seen in landscape pictures with a far horizon, in which haze makes distant parts of the scene appear paler. It helps to add the illusion of depth and distance to photographs.

Angle of view The amount of the subject that is encompassed by a particular lens, or lens setting on a zoom. A wide-angle has a greater angle of view than a telephoto.

Aperture A gap of variable diameter formed by an arrangement of overlapping metal leaves set within the lens. Changing the size of the aperture controls the amount of light reaching the film.

Aperture-priority mode A type of automatic exposure system in which the user sets the aperture and the camera selects the appropriate shutter speed to ensure correct exposure.

APS Advanced Photo System. Film format used by some compacts

Autofocus Various systems used in cameras to set the lens focus automatically for any part of the subject positioned in a marked area of the viewfinder. Passive systems work on the assumption that the subject has most contrast when it is sharply focused; active systems emit an invisible beam of infrared light to measure subject distance.

Available light Light naturally available for photography – daylight or domestic lighting, for example, but not flash or other types of photographic lighting.

Backlighting Light illuminating the back of the subject in relation to the camera position. This type of lighting is encountered most often in photography when the subject is positioned between the sun and the camera.

Backlighting compensation A control found on many compact cameras and SLRs. It selects a wider aperture (or slower shutter speed) to compensate for the fact that the

side of the subject facing the camera is in shadow, and so prevents it from being recorded as too dark and underexposed.

Bounced light A lighting technique in which light is reflected from a surface before reaching the subject. This term most often refers to light from an add-on flashgun, the head of which is angled to point at a wall or ceiling. The resulting light is softer than that obtained from direct flash.

Bracketing A series of pictures taken giving both greater and less exposure than that recommended by the exposure meter.

B setting A shutter control found on SLRS and some compacts that keeps the shutter open for a manually timed exposure. Used for exposures lasting many seconds or minutes.

Byte Standard measurement of memory in digital storage devices. Digital camera memory is usually measured in megabytes (1024 bytes), or gigabytes (1024 megabytes).

C D

CCD Short for Charge Coupled Device. Light-sensitive chip commonly used in digital cameras.

CMOS Short for Complementary Metal Oxide Semiconductor) Light-sensitive chip used by some digital cameras instead of a **CCD**.

Colour cast A false, overall colour on a print. This may result from incorrect printing or, for example, bouncing light from a flashgun off a coloured surface.

Colour temperature A measurement of the colour of light, usually measured in Kelvin (K). Digital cameras compensate for different colour temperatures using a automatic (or manual) white balance system. With colour film, filtration is needed over the lens or during printing to avoid colour casts that would be created by

some colour temperatures of light.

Compact camera A small, highly automated camera with a non-interchangeable lens, and a direct-vision viewfinder.

Depth of field The area of acceptable sharp focus both in front of and behind the point of true focus. Depth of field varies, depending on the lens aperture, focal length and focus distance. Greatest depth of field results from using the smallest aperture, shortest focal length and farthest focus distance.

DX film 35mm film cassettes have a printed set of squares that are detected by sensors in the film chamber of modern cameras. Each speed of film has a unique combination of squares, allowing the camera to read and set this information on the exposure meter.

E F G

Exposure The amount of light reaching the film, resulting from a combination of the aperture used and the shutter speed set.

Exposure meter A light-measuring device, found in or on the camera, which detects the amount of light reflecting back from the subject. On automatic cameras, this information is translated into an aperture and shutter speed to give correct exposure.

File format The language in which a digital image file is saved. Formats commonly used by digital cameras are JPEG, TIFF and RAW. The format affects which programs can open the file, the detail of the image, and the amount of memory required to store it.

F numbers A series of numbers used to describe the size of the lens aperture for a particular focal length. Small f numbers (such as f2.8 or f4) indicate a large aperture, and high f numbers (such as f11 or f16) indicate a small aperture.

GB Short for gigabyte. See **Byte**.

Graduated filter A special effects lens filter that graduates in the strength of its colour, sometimes leaving an area of clear glass.

H I J

High-key A photograph in which colours or tones are mainly light; an effect that may be emphasized by slightly overexposing the film.

Highlight A particularly bright part of an image.

Hot shoe A metal clip on the top of an SLR to hold an accessory flashgun or sensor. Electrical contacts in the base of the shoe trigger the flash to fire when the camera shutter is open.

Hot spot A localized area of intense brightness as strong light, from the sun or a flash, shines back from a highly reflective surface such as glass or metal or, to a lesser extent, from a shiny patch of skin on, say, your subject's face.

ISO An abbreviation for International Standards Organization. A scale used to denote the speed, or sensitivity to light, of film and the image sensors of digital cameras.

JPEG Joint Photographic Experts Group. A digital file format used by digital cameras. The amount of memory needed is less than that required for TIFF or RAW files, as the information is 'compressed'. The amount of compression is variable, with digital cameras offering a choice of 'quality' settings.

L M

LCD An abbreviation for liquid crystal display. Panels found on cameras to display information on shutter speed, aperture, exposure mode and so on selected on the camera. Colour LCDs are used to preview and replay images taken with digital cameras.

Lens speed See **Speed**.

Low-key A photograph in which colours or tones are mainly dark; an effect that may be emphasized by slight underexposure.

Macro lens An SLR lens especially designed to be able to focus at very close subject distances.

Maximum/minimum aperture The largest/smallest aperture available on a particular lens, indicated by the lens's smallest/largest f number.

Megapixel Units used to measure the maximum resolution of a digital camera's CCD or CMOS image sensor; equivalent to a million pixels.

MB Short for megabyte. See **Byte**.

Modelling Usually refers to the areas of light and shade or different strengths of colour that help to define the form of the subject.

N O

Negative A film image showing reversed subject tones or colours. Bright areas of the subject, therefore, appear dark and dark areas of the subject light.

Neutral density filter A lens filter that reduces the amount of light entering the camera without affecting subject colours.

Opening up A term used to describe selecting a wider lens aperture by setting a smaller f number (changing from f11 to f8, for example).

Overexposure Allowing too much light to reach the image sensor or film, giving rise to a pale image.

P R

Panning Moving the camera to keep pace with a subject while the camera's shutter is open.

Parallax error The difference in view between the scene encompassed by the lens and that seen through the viewfinder. This may result in compositional errors, such as cutting off the top of the subject's head, especially at close focusing distances.

Pixel The basic unit used to measure the resolution of a digital image or camera. Each pixel is created by a single light-sensitive image, or photosite, in the digital camera's image sensor.

Program mode Exposure mode where the camera sets both the aperture and shutter speed automatically to suit the measured lighting intensity in the scene.

RAW Digital image file format used on digital SLRs. A high-resolution proprietary format that stores image data in a semi-processed state, allowing certain camera settings to be altered using compatible computer software without affecting image quality. Uses more memory than **JPEG**, but less than **TIFF**.

Red eye The red appearance of the subject's eyes seen in images taken with flash.

Reflector Any material or surface used to reflect light from, say, a flashgun on to the subject.

S T

Shutter-priority mode A type of automatic exposure system in which the user sets the shutter speed and the camera selects the appropriate aperture to ensure correct exposure.

Shutter speed A timed period during which the shutter remains open and light from the lens is allowed to reach the film.

SLR An abbreviation for single lens reflex camera.

Speed Refers to the light sensitivity of an imaging chip (or film) or to the maximum aperture of a lens. High ISO settings are considered fast, as are lenses with a wide maximum aperture.

TIFF Short for Tagged Image File Format. High-quality but memory-hungry file format available on some digital cameras.

U W Z

Underexposure Allowing the film to receive too little light, giving rise to a dark print.

White balance System used by digital cameras that adjusts the colour balance of the image being recorded to suit the **colour temperature** of the lighting

Zoom lens A lens with a variable focal length.

Index

Acknowledgements

The author is grateful to the following people for their help in producing this book:

David Ashby and Anthony Duke for the illustrations and diagrams; Geoff Dann for the studio photography; Hilary Bird for compiling the index; Roger Bristow, Bob Gordon and Rod Teasdale for their design work; Auberon Hedgecoe; Chris George for his assistance in writing the book; and Sarah Hoggett for editorial work.

In addition, he would like to thank the following companies for the loan of photographic equipment:
Pentax UK Limited and Olympus UK Limited.